W9-COE-558

Kodak
Pocket Guide to
Travel Photography

by the Editors of
Eastman Kodak Company

Simon and Schuster / New York

Copyright © 1985 by Kodak Limited

All rights reserved
including the right of reproduction
in whole or in part in any form.

Published by Simon and Schuster
A Division of Gulf and Western Corporation
Simon and Schuster Building
Rockefeller Center
1230 Avenue of the Americas
New York, New York 10020

Simon and Schuster and Colophon are registered trademarks of
Simon and Schuster

Library of Congress Cataloging in Publication Data
Main entry under title:

Kodak Pocket Guide to Travel Photography

Includes index.
1. Travel Photography — Handbooks, manuals, etc.
I. Eastman Kodak Company
TR790.K63 1985 778-9'991 84-23471
ISBN 0-671-50669-2

Manufactured in the United States of America

1 2 3 4 5 6 7 8 9 10

Kodak Limited, Author
Written for Kodak by
Robert Adkinson Limited
Text : Michael Busselle (RAL)

Editors, Susan Victor (S&S), Richard Platt (RAL)

Editorial: Keith Boas (Kodak)
 Kenneth Oberg (Kodak)
 Jacalyn Salitan (Kodak)
Designer, Michael Rose (RAL)
Production: Charles Styles (Kodak)
 Howard M. Goldstein (S and S)

Photo credits: all pictures by Michael Busselle, except the following:
page 48: Adam Woolfitt; page 49 John Marmaras; page 65 (bottom)
Jim Anderson; (top) Stephen Morley; page 102 North Sullivan.

The Kodak material described in this publication for use with
cameras are available from those dealers normally supplying
Kodak products. Other materials may be used, but equivalent
results may not be obtained.

KODAK, EKTACHROME, KODACHROME and KODACOLOR are
trademarks.

CONTENTS

INTRODUCTION

Vacations, business trips, weekend outings, in fact journeys of any kind always provide special opportunities for the camera. Everything seems new and somehow special — different from how it is at home. Even the familiar faces of traveling companions seem more picture-worthy in new surroundings.

Traveling tests your photographic skills to the limit, because there's always an enormous variety of subjects that you'll want to take pictures of. Even if you normally use a camera only to make portraits, you'll probably want to take at least a few pictures of the countryside you travel through, or the cities you visit. Every day will bring a new photo-challenge, and there are bound to be new subjects or problem situations that you can't cope with unaided.

This little book provides the answers. From it you'll learn useful tips and techniques to help you handle those difficult or unusual situations with your camera — whether it's a simple snapshot model, or a sophisticated SLR. You'll learn how you can make images of the traditional tourist sites more imaginative than the picture-postcard clichés; and how to catch the vivid colors of the sun setting over a horizon far from home.

Here you'll also find original picture-taking ideas that help you to make a fascinating and integrated travelogue, rather than just a series of disjointed picture souvenirs. You'll read how you can use several pictures instead of just one to better describe places you visit and people you meet. Carry this pocket guide with you and refer to it often so you can get more out of your camera and bring back a record of your travels that you can look back on with pleasure in years to come.

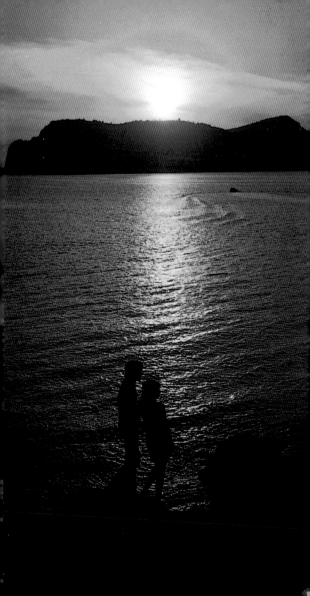

CHOOSING A CAMERA

Picking a camera for travel means thinking about your picture-taking from a new viewpoint. For example, when backpacking, you must carry all of your belongings on your shoulders, and won't want to add a heavy camera to that burden. Or you may have a special reason for making your trip, and demand special capabilities from the camera — such as the ability to fill the picture with an image of a small object.

Before making any decision, think about what sort of pictures of your trip you want to bring home. If you want postcard-size prints to put in an album, almost any camera will fit the bill. But for larger pictures and for projection onto a screen, consider a 35 mm model. You'll get better quality from the larger-format 35 mm film.

Think too about how you are going to carry the camera. For ease of use and pocketability, it's hard to beat a KODAK Disc Camera or 110-size pocket camera. Compact 35 mm cameras are nearly as simple to use, but a little more bulky.

A possible disadvantage of these auto-only cameras is that they limit your photography — the camera, not you, makes the decisions regarding exposure. If you are prepared to carry the extra weight, you'll find that a 35 mm single-lens-reflex provides greater versatility.

Vacation Snapshots
For sunlit scenes such as this, you don't need an advanced camera, and an automatic model makes picture taking virtually foolproof.

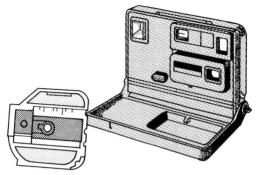

Disc Camera

The most compact and handy cameras of all use wafer-thin disc film. These cameras are very simple to use — most functions, including film wind, exposure setting and flash, take place automatically.

110-size Pocket Camera

These are almost as small as Disc cameras, and loading is as easy — you drop in a small cartridge. Again, most functions are pre-set or automatic for ease of use, but this can sometimes limit the camera's versatility.

Compact 35 mm Camera

35 mm film is bigger than Disc and 110, so you'll get clearer pictures. There's a wider choice of films, too. However, 35 mm cameras are heavier, costlier, and may be no more versatile than smaller cameras.

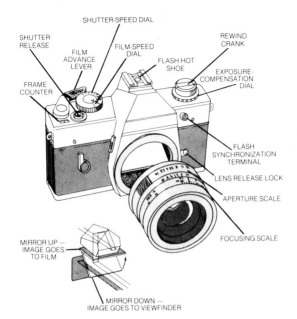

SHUTTER-SPEED DIAL

SHUTTER RELEASE

FILM ADVANCE LEVER

FILM-SPEED DIAL

REWIND CRANK

FLASH HOT SHOE

EXPOSURE-COMPENSATION DIAL

FRAME COUNTER

FLASH SYNCHRONIZATION TERMINAL

LENS RELEASE LOCK

APERTURE SCALE

FOCUSING SCALE

MIRROR UP — IMAGE GOES TO FILM

MIRROR DOWN — IMAGE GOES TO VIEWFINDER

A simple or automatic camera is fine for casual vacation photographs and family momentos, but sometimes the very features that are designed to make the camera easy to use can actually hold back your creativity. Single-lens-reflex (SLR) cameras like the one shown above are designed to get around this problem, and to give your imagination a free rein. Most are simple to operate, too.

At the heart of an SLR camera is a mirror and a prism that together relay the image from the camera's lens to the photographer's eye. To make the picture, the mirror briefly swings up out of the way so that the image-forming light can reach the film, (above left). The viewfinder therefore, shows exactly what the lens sees, making focusing and composition especially easy — even in close-up situations. And since the lens is removable, you can swap it for a wide-angle one to get a broader view of the subject, or for a telephoto one to close in on a distant detail. A built-in meter takes care of exposure settings, but most models have manual exposure override for when you want total freedom of expression.

Bigger Cameras — Bigger Film

The 35 mm SLR has a bigger brother, the rollfilm SLR. This has a more boxy shape, and takes pictures up to five times larger than those shot on 35 mm film as shown life-size below. The larger pictures give the quality often needed for book and magazine reproduction, so many professional travel photographers are prepared to put up with the extra weight and cost of these large-size SLR's.

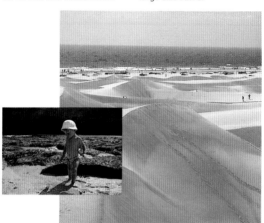

Changing Lenses

By removing the standard lens from an SLR, and replacing it with a different one, you can change the camera's field of view. Both pictures shown here were taken from the same spot. The photographer used a 20 mm wide-angle for the left-hand picture, and a 180 mm telephoto lens for the right-hand one. The camera's reflex viewfinder showed the changed field of view exactly as it appears in these pictures.

CAMERA BASICS

Why bother to learn about your camera and how it works? After all, most of today's cameras are so sophisticated that they automatically take care of the exposure controls, and some even focus the picture unaided. Clever though these cameras may appear to be, they work perfectly only with average subjects, in average lighting. As the pictures below show, unusual conditions can easily fool the most advanced cameras into the wrong exposure, thus ruining what would otherwise have been a great photograph.

In your own backyard, a spoiled picture may not matter — you can usually go out and take another. But thousands of miles from home, you may get picture opportunities that are literally unrepeatable. A little knowledge of camera basics will go a long way in helping you bring back on film acceptable images of what you saw in the viewfinder.

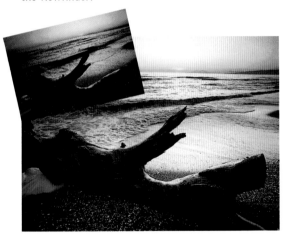

Controlling the Picture

Automatic cameras work fine in average situations, but who wants pictures that are just average? Pointed towards the setting sun, an automatic camera was misled by the high contrast of dark and light, and made a disappointing image (top). When the photographer set his camera to **manual** and gave more exposure, he produced a much more lifelike and attractive photograph.

The Shutter

To make a good picture, film in a camera must receive just the right amount of light: the right intensity, and the right amount of time. To control how long light falls on the film, every camera has a shutter. In the very simplest cameras, the shutter opens for a fixed time, generally about 1/100th of a second. This is known as the shutter speed, and is usually written. just as 1/100.

More sophisticated cameras give the photographer a choice of speeds, typically ranging from 1/1000 to 1 full second. The speeds are marked on the camera as numbers: 1000, 500, 250 . . . and so on, often through to 1 (1 second). Each consecutive or preceding setting doubles or halves (respectively) the time that light reaches the film, so that 1/125 allows light into the camera for twice as long as 1/250, and half as long as 1/60, as shown.

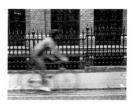

Shutter Speed and Movement

The shutter controls the action-stopping ability of the camera. Slow shutter speeds (above) record moving objects as a blur. Fast speeds (below) freeze movement.

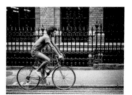

Camera Shake

At slow shutter speeds, vibration from your hands can shake the camera, causing a blur. For shake-free pictures when using the camera's normal lens, don't use speeds slower than 1/60.

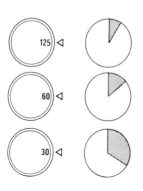

Focusing

To take sharp pictures, your camera lens must be at just the right distance from the film. The ideal separation between the lens and the film depends on how far you are from the subject: moving the lens away from the film makes nearby subjects sharp, but blurs distant ones; whereas bringing the lens and film closer together records distant subjects sharper than close ones. This is the process of focusing.

Simple cameras have fixed lenses, and cannot make clear pictures of extremely near objects. If your camera is of this type, you should avoid subjects closer than about four feet (see your camera instructions for details). Most cameras, though, have adjustable lenses that move in and out to control which part of the picture is sharpest. A distance scale or a row of symbols show where the lens is focused. On many new cameras, focusing is automatic — the camera senses the subject distance and sets the lens accordingly.

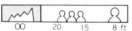

Background Sharp

Keep distant scenes sharp by setting the infinity (∞) or the mountain peak symbol.

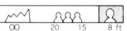

Close Subjects

Estimate the distance and set on the feet scale, or use the "head-and-shoulders" symbol.

Focusing Aids

SLR cameras (additionally) have a focusing screen on which you can watch the subject move in and out of focus when you turn the focusing ring.

To aid focusing, the viewfinder of an SLR camera incorporates a split-image rangefinder which breaks out-of-focus subjects in half. Turning the focusing ring realigns the two halves, indicating sharp focus, as shown below.

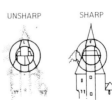

UNSHARP SHARP

The Aperture

Sandwiched between the glass components of a camera lens is an adjustable hole — the aperture. Making this hole bigger or smaller controls the brightness of the image that reaches the film, as shown below. The brightness is important, because film must receive just enough exposure to light — no more and no less.

Together with the shutter, the aperture allows the photographer to accurately control this exposure to light. Like the shutter-speed dial, the aperture control has calibrations that run in a halving and doubling series: Each setting on the aperture control ring lets through twice as much light as the one before, and half as much as the one after.

These aperture settings are called f-stops, and are numbered so that large apertures have small numbers, and as the size of the apertures decreases the numbers get bigger. The numbers — which are called f-numbers — run in a series that is similar on most lenses: 1.4, 2, 2.8, 4, and so on, to 16, 22, or 32.

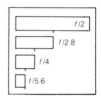

Aperture and Depth of Field

Choice of aperture also affects the sharpness of the image. Although subjects at just one distance from the camera are especially sharp, there is a band of acceptable sharpness on each side of the point on which the lens is focused. This zone of acceptable sharpness is called the depth of field, and depends on the aperture that you choose. Large apertures (small f-numbers) produce the least depth of field. Small apertures, such as f/11 or f/16, create more depth of field, so that more of the picture is sharp, as shown below.

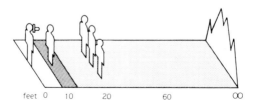

feet 0 10 20 60 ∞

UNDERSTANDING EXPOSURE

We've already looked at the two camera controls that limit how much light get to the film. But we haven't yet considered how to choose the best setting for the aperture and shutter-speed dials. Most times you won't actually make this decision yourself — the camera will pick one or both of the settings for you. But with very dark or light subjects, the camera can choose the wrong setting, so it is better to take control and set aperture and shutter yourself, as shown below, opposite.

How you choose the right combination of shutter speed and aperture depends on just two factors: the amount of light falling on the subject and the sensitivity of the film in the camera. On a sunny day, the scene you are photographing is very bright, so you can use a small aperture or a fast shutter speed to cut down the light reaching the film. In dim conditions, though, you must use a wide aperture and a slow shutter speed to allow enough light to reach the film, or switch to a higher speed film.

Your camera's meter co-ordinates these four factors: brightness, film speed, aperture and shutter. Once you have set the speed of the film on the camera's ISO (ASA) dial, the meter can measure the amount of light reflected from the subject, and recommend a suitable combination of aperture and shutter speed. The meter suggests just one particular combination of shutter speed and aperture, but others will give equally good exposure, as the diagram at right explains. Your final choice will depend on the type of subject you are photographing as shown below.

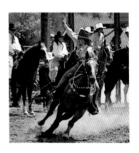

Action or Depth?

Both pictures were taken with similar light and film. To freeze action (above) required a fast speed — 1/1000 — and an aperture of $f/4$. When depth of field was more important (left) a small aperture ($f/16$) and a slow speed (1/60) gave a better result.

Shutter and Aperture Together

To understand how a shutter speed and aperture complement each other, think of a faucet filling a bucket. The more you open the faucet, the faster the water flows — and the quicker the bucket fills. In a similar way, opening the camera's aperture lets more light in — so the shutter needs to be open for a shorter time to expose the film. The "doubling and halving" settings of the shutter and aperture controls make this principle easy to put into practice. If you want to alter the shutter speed, but keep the exposure the same, you need only change the aperture by an equal amount.

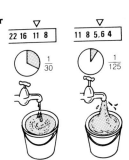

For example, if your meter indicates that 1/60 second at f/8 will give correct exposure, then 1/30 second at f/11 will give equal exposure — as will 1/125 second at f/5.6.

Dark and Light Subjects

Unusual subjects fool your camera's meter, and you must alter exposure to compensate. Give light subjects (left) 1 stop extra exposure by setting the ISO (ASA) dial to half the film speed. With dark subjects (right) double the film speed to give 1 stop less exposure. Your camera may have a compensation control on which you can dial in these corrections.

CAMERA HANDLING

When you're on the move, things can happen suddenly — and when you least expect them. When you see an amusing street scene such as the one at right, it's not a good time to fumble with a new or little-used camera: Only if you are completely comfortable and familiar with your camera can you devote your full attention to the subject and take pictures that successfully evoke the atmosphere and flavor of the trip.

Holding the Camera

Picture-taking begins when you pick up the camera — a well-chosen grip can reduce camera shake, enabling you to get blur-free pictures at slower shutter speeds. Hold the camera firmly and comfortably, and press your arms against your chest to provide extra support.

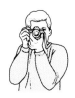

Position your fingers so that you can reach all controls without having to take the camera away from your eye, or change your grip. Several alternative postures are shown at right. You might find it helps to try out these different ways of supporting the camera in the vertical and horizontal modes, until you find the position that suits you best.

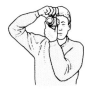

Good Camera Habits

Simple mistakes can easily spoil your pictures, so try to develop a fail-safe routine that guards against errors.

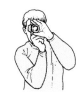

Read the Instructions

packed with your camera, and take the booklet with you when traveling, until you're absolutely confident that you know how each control operates.

Check Film Advance after loading by watching the rewind crank. After you've shot a few frames, the rewind crank should turn each time you wind to the next frame.

Preset the Controls to suit the prevailing light. With programmed automatic cameras this is unnecessary, but with other types, you need to set either the shutter or the aperture — and the camera chooses the other setting for you. With aperture-priority cameras, make sure that your choice of aperture does not force the camera to set a speed that is too slow to hand-hold, or else your pictures will be spoiled by camera shake. And with shutter-priority cameras, check that the camera is setting an aperture small enough to provide sufficient depth of field. With both types, extreme settings can lead to under- or over-exposure, so avoid settings such as 1/1000 second or f/16 in dim light, and 1/30 second or f/2 in bright light.

Grab Shots

To be sure of catching scenes like this, keep controls set mid-way, as shown below, thus minimizing last-minute changes.

Between Films, check out the camera. Open the back, and look towards the lens. Then turn the aperture ring to its smallest setting (highest f-number) and set the shutter to ½ or 1 second. When you press the shutter release, the shutter should open, and the aperture close down to a small hole. Operate the shutter at faster speeds, and check visually that these too function normally.

WHICH FILM?

There may seem to be a bewildering variety of films on a photo dealer's shelves, but really the choice is quite simple. If you want economical color prints to hand around among friends, choose color negative film. But if you'd rather project your photos on a screen, then pick slide film, such as KODACHROME 64 Film. You can always make prints from your favorite slides, though this is rather more expensive than printing from negatives. The third choice, shown in the box below, is black-and-white film, yielding negatives from which prints can be made.

Each of these film types comes in several sizes and in several different speeds. The speed you pick will depend on the lighting conditions in which you take pictures: the darker it is, the faster the film you'll need, as explained opposite.

Slides or Prints?

If you have a simple, non-adjustable camera, color negatives are the best choice. Print film is very forgiving of exposure errors, giving good results in most conditions. Slides, on the other hand, produce the very best in quality, but demand more disciplined technique for good results — and you need to use a projector or viewer to see your pictures clearly.

Expressive Black-and-White

Don't pass over black-and-white film as being old-fashioned. An image in monochrome often can better express the mood and atmosphere of a place than can a picture in full color. Black-and-white film is simpler to process and print at home, too.

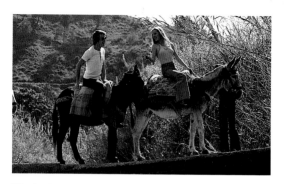

Film for General Use

Most travel pictures are taken in lighting of average brightness, where film speed is less important. So for the bulk of your film supplies, choose a medium-speed film such as KODAK EKTACHROME 100 Film or KODACOLOR VR 200 Film. These films give sharp, richly colored pictures over a wide range of picture opportunities.

Low-Light and Fast Film

A film's speed is a measure of its sensitivity to light and is printed on the film box as an ISO (ASA) number. The higher this number, the more sensitive the film. It's always worth packing a roll of super-fast film, such as KODACOLOR VR 1000 Film just in case; with fast film in your camera, you can catch the atmosphere of nightlife without using flash.

Keep It Cool

To get the best results from film, don't let it get too warm. When traveling in hot climates carry only as much film as you think you'll need for the day. The rest should stay in an air-conditioned hotel room, a refrigerator, or in an insulated picnic cooler. Never leave film inside an auto in the sun — temperatures can soar to oven-like levels.

USING DIFFERENT LENSES

Changing the lens on a camera lets you photograph a sweeping landscape in a number of ways. Exchanging a normal lens for a wide-angle lens extends the boundaries of the picture, so that the camera takes in a broad view and recalls the spreading magnificence of the scene. Changing to a telephoto lens has the opposite effect — the lens acts like a telescope, magnifying the interesting little details that give the scene texture, proportion, and a human scale.

Of course, by changing lenses, you can improve other travel pictures besides landscapes. For example, you can use a telephoto lens to pick out just one exotic face from a crowded street market. Or a wide-angle lens to photograph the whole interior of a baroque cathedral, instead of filling the frame with a small detail.

Different lenses change the picture in more subtle ways as well. Telephoto lenses seem to compress the view, bringing close together objects that are in reality quite far apart. Wide-angle lenses have greater depth of field than normal lenses, so that you can keep in focus both near and far subjects.

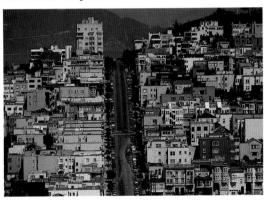

Perspective and Telephotos

Seen from afar through a telephoto lens, subjects look more tightly packed than when photographed through a normal lens from a closer viewpoint. This picture of San Francisco was taken using a 400 mm lens.

Telephoto Lenses

To see how much a telephoto lens will magnify the subject, look at the front ring, where you will find engraved the focal length in millimetres. This lens has a focal length of 200 mm, four times that of a 50 mm lens, normal focal length for 35 mm cameras. So this lens magnifies the image of the subject by four times. The most common telephoto lenses have focal lengths of between 100 mm and 500 mm. Longer lenses are large and unmanageable, and shorter ones have too moderate a magnifying effect. For the traveler, a 135 mm or 200 mm lens offers a sensible compromise between size and weight, and the power to pull in distant details.

The more a telephoto lens magnifies, the more it cuts down depth of field. Focused on a subject 10 feet (3 m) away, a 200 mm lens has a zone of sharp focus just 2 inches deep. This is not always a disadvantage, though, as the picture at right shows.

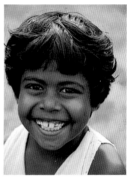

Telephoto Portrait
You can use the shallow depth of field of a telephoto lens to blur a distracting background in a portrait.

Holding the Camera Steady

Telephoto lenses magnify camera shake, just as they magnify the subject. So you must take special care to support the camera firmly when using a telephoto lens. Use a tripod, or improvise a camera support using the back of a chair, a wall, or the side window of an auto. Cushion the camera using a rolled-up coat.

Wide-angle lenses

Wide-angle lenses have focal lengths of less than 50 mm. The shorter the focal length of the lens, the broader is the field of view. Popular lenses have focal lengths of 35 mm, 28 mm, and 24 mm, and though you can buy lenses as short as 13 mm, these "ultrawides" are very expensive, and often cause unsightly distortions of the subject.

35 mm lenses have a very moderate effect. So moderate, in fact, that many travel photographers use a 35 mm lens in place of a normal lens. The broader field of view makes the lens easier to use in crowds, yet without the pronounced perspective

distortion that shorter focal lengths sometimes produce.

28 mm and 24 mm lenses have progressively broader fields of view, and one of these two is usually the first choice of photographers who wish to supplement their basic outfit of camera and normal lens.

Either lens is a good choice for the traveler. Each is well suited to the photography of buildings, both inside and out; and both have enough depth of field that at medium apertures, focusing adjustments are needed only when the subject is close to the camera. At normal distances, you can just "aim and shoot."

Keep Near and Far in Focus

Wide-angle lenses have plenty of depth of field — so it's easy to keep everything sharp.

A 24 mm lens, though, is a little more difficult to use. You have to take extra care to keep the camera level, or vertical lines will appear to converge towards the top or bottom of the frame, as at right. 24 mm lenses can also distort subjects at the edge of the frame. Circles in particular look stretched to ovals.

Distortion and Wide-angles

Tilt the camera steeply up, and you can use wide-angle distortion for creative effect.

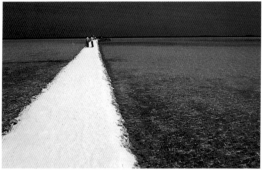

Wide-angle Composition

Use the "stretching" effect of wide-angle lenses to make bold images. Here the receding lines draw the viewer's eye to the two distant figures.

Expanding Space

You can exploit the unique characteristics of wide-angle lenses to create pictures that have a tremendous sense of space and openness. Move in close, and foreground subjects appear large in the frame. Position the camera close to the ground or a wall, and the flat surface seems to rush away into the distance.

Even when the main subject is quite close to the camera, scenery in the background remains sharp; so you can juxtapose near and far in one picture. For example, you might choose to set off iced drinks on the table of a street cafe with a distant view of the harbor.

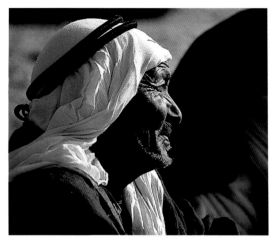

Zooms for Portraits

When composition must be just right, a zoom lens has the edge. With it, you can fine tune the image size to crop the picture as you please.

Zoom Lenses

For the traveler, a zoom lens has special advantages. Zooms don't have just one focal length, but a whole range, so you can adjust the size and framing of the subject simply by turning a ring on the lens barrel. A zoom lens can thus replace two or three conventional lenses of fixed focal length. A popular choice is the 70-210 mm zoom such as the one shown above. With the lens set to 70 mm, family portraits are possible without moving back to shouting distance. Yet at the other extreme of focal length, architectural details high up on a building are magnified enough to fill the frame. Zoom lenses aren't for everybody though. It's true that one zoom lens is lighter than the three lenses it replaces, but the zoom will invariably be bigger and more expensive than any one of the three. Also, only the most expensive zoom lenses can match fixed focal length lenses for quality.

Teleconverters

Like zoom lenses, teleconverters are of particular value to the traveling photographer, because they save weight and

bulk. A converter lens fits between the camera and the main lens, and increases the focal length by a factor of usually 1.4X or 2X. So a 200 mm lens becomes a 280 mm or 400 mm.

Quality of pictures taken with a converter is never as good as those taken with a lens by itself, but closing the main lens to a smaller aperture usually improves sharpness considerably.

All converters reduce the amount of light reaching the film: a 2X teleconverter, for example, reduces light by two stops, so a slower shutter speed — and therefore extra camera support — are essential.

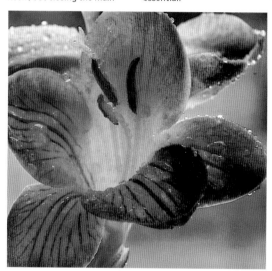

Macro Lenses

Most lenses focus no closer than about 18 inches, filling the picture with subjects about a foot across. Macro lenses, though, are specially made to close in on tiny subjects such as the flower shown above. Usually a macro lens takes in a field of view just less than 3 inches across at the closest focusing distance, yet focuses out to photograph distant subjects like any other lens.

Macro Flowers

A macro lens lets you fill the frame with a tiny bloom like this one, yet doubles as a regular 50 mm or 100 mm lens.

CHOOSING FILTERS

The very best travel pictures show a trip as you'd most like to remember it: golden beaches and sunsets; blue skies and twinkling night lights. Taking really great pictures like these, rather than ordinary snapshots, means interpreting the scenes you see, and capturing a personal view of the places you visit. The simplest and one of the least expensive photo accessories — filters — make it much easier to do this.

You can use a filter to enhance an already-picturesque scene: by making colors deeper and richer; by cutting out glare and unwanted reflections; or by eliminating the overall colored tints that sometimes spoil otherwise-good pictures. Filters can also come in handy when the subject is less than perfect — they turn gray skies blue, or add an extra sparkle to night scenes.

And because filters, unlike lenses, are small, lightweight, and inexpensive, you can afford to take several along with you without breaking your back or your bank balance.

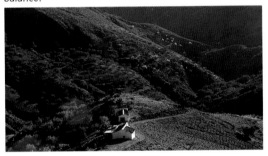

Everyday Filters

The two most useful filters of all look almost colorless. These are the clear UV filter, and the pale-pink skylight filter. Both filters cut out ultraviolet (UV) radiation that is present in sunlight. On film, UV can cause a slight overall blue color — a blue cast — particularly near the sea and at high altitudes. Skylight and UV filters absorb the UV radiation, and prevent the color cast.

Beating the Blues

Fitting and almost-colorless skylight or UV filter prevents pictures such as this from looking excessively blue.

Fitting Filters

Most filters just screw into the front of your lens.

Balancing Color

Most film gives its best results when midday sun or flash illuminates the subject. The film sees both of these types of light as white — whereas other types of light appear as slightly different colors. Light from an overcast sky is bluer, for example, and household lamps give out a warm yellow glow. Both of these light sources, and other off-white lights, will create unwanted color casts on film. With color negatives, the hues can be partially corrected in printing; but with any color film, you get better results if you use a filter over the lens to eliminate the color imbalance. The chart at right shows which filter to use for different light sources, but with just three filters you can cope with most conditions. An 80A or 80B filter eliminates much of the orange color from pictures taken indoors where a light bulb illuminates the scene. An 81B or 81C filter takes out the blueness from pictures shot in cloudy weather, or when the subject is in the shade on a sunny day. And an FLD or 30 magenta color-correction filter makes pictures taken by average fluorescent light seem less green.

Yellow Interiors

Without filtration, tungsten light appears yellow on film — but daylight looks normal.

WITH POLARIZING FILTER

WITHOUT POLARIZING FILTER

Adding Color

A polarizing filter acts like a pair of glare-cutting sunglasses: it cuts out reflections from water, glass, and most other shiny things, except metal. A polarizing filter has another unexpected result, too. It makes the colors of a blue sky and sunlit foliage seem richer and brighter, as shown above, and cuts through the slight haze that often hangs over distant views. Look through and rotate the filter to see when its effect is strongest, then fit the filter to the lens in the same orientation. With an SLR camera, just turn the filter on the lens while looking through the viewfinder.

Previewing the Picture

Diffraction, starburst, graduated, and other special-effects filters produce slightly different images at each aperture, and if you have an SLR camera, you can preview the finished picture using the stop-down control. This closes down the aperture from its widest setting — which is always used for viewing and focusing — to the aperture that you have pre-set on the control ring. When you operate the control, the viewfinder darkens, but this does not affect the picture that you take. Once your eyes get used to the dimmer image, you will have a clearer impression of how your picture will look.

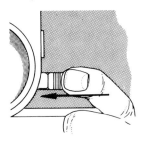

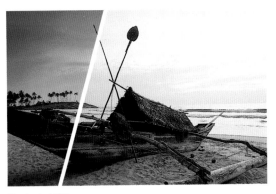

Graduated Filters

Graduated filters are not one color all over. Instead they are colored at one side, and gradually fade to clear at the other side. This means that you can tint one half of a picture in the color of the filter, while leaving the other half unaffected. With the rectangular filters, you can even position the transitional area exactly where you choose in the frame.

The change from colored to clear appears most gradual with telephoto lenses, whereas with wide-angle lenses the transition is much easier to see in the picture. The most useful graduated filters are the paler ones — deeper colors tend to look false. Use a graduated neutral gray filter to darken skies without affecting color, and a blue one to brighten images on dull days. Tobacco-colored graduated filters turn the sky stormy, and yellow or red ones brighten up a sunset.

Sparkling Sunlight

To make light sources and their reflections sparkle and twinkle, use starburst or diffraction filters. These are engraved with fine lines which catch each source of light and spread it into brilliant sparks, as in the picture at left.

The more lines there are, the more rays emanate from each light source.

Diffraction filters are more costly than starburst filters, but they have an added attraction. Seen through a diffraction filter, the rays from each light source spread out in rainbow colors.

Filters for Black-and-White Pictures

Black-and-white film normally records subjects of equal brightness as similar shades of gray, regardless of color. Thus a red object will appear in the print about the same shade of gray as a green object of the same brightness. This can sometimes have unexpected results, making a scene that was quite contrasty and bright appear dull and flat in monochrome.

With a filter, though, it is possible to alter the film's response to individual colors — darkening some, and making others lighter — to create greater contrast between the tones. A filter will allow light of its own color to pass freely, but absorbs light of other colors, so that a red filter, for example, absorbs green light, but not red.

With a red filter on the lens and black-and-white film in the camera, red objects will

look lighter, and other colors darker.

The most common filters for black-and-white photography are yellow and orange — use them to darken blue skies so that clouds look whiter. Red filters have a similar, though more dramatic effect, turning a blue sky almost black. Green filters make people look suntanned, darken red flowers and lighten foliage.

HOW TO USE FLASH

Toting a small flash unit is like traveling with a "tiny bit of the sun" in your camera bag — wherever you are, you'll have enough light to take a photo. And with today's faster films, using flash doesn't limit you to subjects close to the camera, because the beam of the flash reaches out to light subjects 20 or 30 feet (6 or 9 metres) away. Flash has a role to play by day, too: use it to fill in the dark shadows cast by direct sunlight.

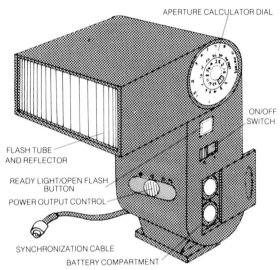

APERTURE CALCULATOR DIAL

ON/OFF SWITCH

FLASH TUBE AND REFLECTOR

READY LIGHT/OPEN FLASH BUTTON

POWER OUTPUT CONTROL

SYNCHRONIZATION CABLE

BATTERY COMPARTMENT

Dedicated Flash

If you have quite a new camera, you may be able to buy a dedicated flash for it. Such units operate with only one brand of camera — often just one model. Besides synchronizing the flash with the shutter's opening, such units simplify and automate flash photography. The unit will automatically set the shutter to the correct synchronization speed, and may illuminate a 'flash ready'

light in the viewfinder. If you have a dedicated flash unit, some of the steps at right are unnecessary — read the instructions supplied with the unit to find out which. Dedicated flash units have extra contacts which connect with matching contacts on the camera's hot shoe.

Setting up for Automatic Flash

To operate properly, your camera and flash unit must be linked electronically, so that the flash fires at the exact moment when the shutter is open. This is called synchronization. You can make the connection in two ways: by plugging the flash synchronization cable into a matching socket on the camera (1); or by simply sliding the flash unit into the camera's accessory (2) shoe.

1

If the accessory shoe has more than one metal connection, as shown below at left, take special care when you do this; because if the flash is switched on, you could cause serious electrical damage. Read the camera instructions carefully first.

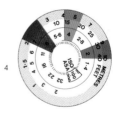

2

Having connected the two units, set the shutter to the synchronization speed or slower. This speed is marked on the dial with an 'X', a lightning-bolt symbol, or a different color engraving to the other speeds (3). The synchronization speed is usually 1/60 or 1/90 second, but on a few cameras it can be as fast as 1/125 or even 1/250 second.

3

Next look at the calculator dial on the flash unit (4), and set it on the speed of the film in the camera — eg. ISO 100. With the film speed set, you can read the choice of apertures available (though on the simplest units, you may have no choice). Choose an aperture, set this on the camera, and make the corresponding setting on the flash unit. For example, here the photographer has picked the option marked in green — f/4 — from a choice of three marked in different colors. Setting the dial on the front of the flash to green (5), programs the flash to give just enough light for the correct exposure when the camera lens is set at f/4. Finally, check that the subject is not too far away. The maximum distance in this example is 15 feet (4.5 metres), shown by the scale alongside the green marking on the calculator dial. If you are out of range, move closer, use a faster film, or pick a wider aperture.

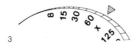

4

5

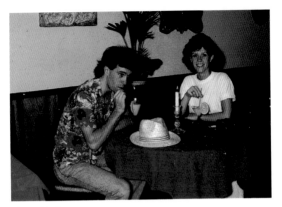

Direct Flash

Fitting the flash directly to the camera is convenient, but direct flash creates dark shadows immediately behind your subject. By being more adventurous with the flash unit, you can greatly improve flash pictures.

Flash Off Camera

Moving the flash off the camera shifts the shadows away from the subject and creates more pleasing lighting. To do this, you'll need a flash extension cable — one that is 4 feet (1.2 metres) long is best. Hold the flash at arm's length, and point it towards the subject.

Long Exposures

Combining flash with a long exposure, such as 1/4 or 1/8 second makes natural room lighting show up more clearly.

However, subject and camera must be quite still, or your pictures will have "ghost" images.

Bounce Flash

With a tilt-head flash, you can bounce light from white walls and low ceilings, creating much softer illumination. Tilt the flash head upwards, and set the widest aperture option available on the flash unit. Keep quite close to your subject to avoid underexposure.

A TRAVELING OUTFIT

Packing for travel always involves some tricky decisions: some people manage with a comb, a toothbrush and a change of clothes; while others burden themselves with what looks like the entire contents of a closet. It's the same with camera equipment. Should you travel light, or try to anticipate every possibility?

Ultimately, the choice depends on individual circumstances — air travelers, for example, can take less than those traveling in an auto — but some photographic requirements are common to everyone.

Saving Weight

If you have special interests, you may feel tempted to carry more than just a basic outfit. However, consider weight and compactness first if you do this. To catch moody night shots like the one above, take a small folding tripod — not a full-size one. A mirror lens is much easier to carry than a conventional long telephoto if you have an interest in wildlife or sports; and a macro lens can replace a normal lens, rather than supplementing it, for photographers who enjoy taking close-ups.

It's always difficult to know how much film to take, but a general rule is to carry double what you expect to use. Film may be more expensive at your travel destination, and the choice is usually more limited than at home.

Choice of photographic equipment depends largely on your interests, and what you already have in the way of camera and lenses. However, a surprising range of subjects can be covered with just one camera and two lenses, particularly if one of these lenses is a zoom. If you already own more equipment than this, think twice before taking it all.

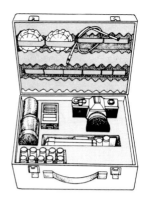

Photographers' Tool Kit

In addition to strictly photographic equipment, it is a good idea to make a collection of other items that are useful for on-the-spot repairs and camera maintenance, as shown.

PLASTIC BAGS FOR STORING EQUIPMENT OR FILM

FABRIC ADHESIVE TAPE

TISSUES AND BLOWER-BRUSH FOR CLEANING

MANY BLADED KNIFE

FLASHLIGHT

SPARE BATTERIES FOR CAMERA AND FLASH

NOTEBOOK FOR CAPTION NOTES

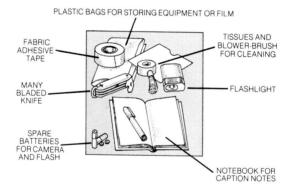

Air Travel with a Camera

If you are traveling by air, try to keep your camera with you: it will be safer from theft or damage. Airline regulations stipulate that cabin luggage must fit beneath the seat, so pack travel documents and anything else you need for the flight in with your camera. There is a size limit: the sum of the length, breadth and height of the bag must be less than 45 inches.

WHERE AND WHEN TO GO

Only a professional — or a real enthusiast — would plan a journey on a purely photographic basis. However, if your itinerary is sufficiently flexible, it's worth timing a trip so that the place you're going to looks at its best. Even if school vacations fix the dates of family travel, you may want to avoid visiting places that don't look their best at these times of the year.

The main things to think about are obviously the weather and the seasons — but don't jump to the conclusion that good vacation weather is necessarily the best for photography. Brilliant summer sunlight, for example, creates small pools of shadow that don't always look good on film.

Even in the city, the changing seasons can affect your pictures. In the summer months, the resident population nearly disappears, leaving you with only other tourists to photograph.

Avoid Mid-Summer!

In temperate latitudes, summer foliage creates a bland uniformity of green; and the constant blue sky, without clouds, makes landscape photography less interesting. Nearer the equator, summer turns the land parched and dry, and adds haze to the atmosphere.

Spring and Fall

These seasons offer a better compromise between a pleasant climate and good photography. The early foliage of springtime gives a greater variety of color and texture than summer and the more changeable weather makes skies and lighting effects more interesting. Some parts of the world are at their best in the fall — woodland countryside in particular offers rich and spectacular colors, and in mountainous regions there is often an early snowfall to set off the russets and browns. Think about the other travelers, too: try to travel

when they don't. Most of the photographs that appear on postcards and in advertisements are made at peak season, and there is always a certain sameness about them.

Off Season

When the crowds have gone you'll have opportunities to take less obvious images that show an aspect of the place that most tourist don't see. Beachside holiday resorts, for example, have a totally different atmosphere when the visitors have gone home: the year-round residents walk through streets that, now emptied of crowds, seem two or three sizes too big.

FINDING GREAT PICTURES

There must be few travel photographers who haven't been told at some time "if only you'd been here last week . . .". Or, on returning home . . . "You went **there**? And you didn't visit that fantastic village just a mile or two down the road?"

Fortunately, you can cut down the risk of this happening by doing some research and planning before leaving — and this will usually add to the pleasurable anticipation that most travelers enjoy.

The first step should be a trip to the library nearest your home. There you can gather information about the area you will be visiting — and, especially important for non-English-speaking destinations, the details will be in your own language.

If you are planning far enough ahead, make your research as localized as possible by writing to a tourist office in the region. If time is a problem, though, the tourist department in a nearby big city will probably respond more quickly. Areas with big tourist industries should also have a wide selection of free information at offices in the main cities of other countries.

But don't stop here. Many specialized organizations can give details of places of unique interest that do not appear in tourist guides. Commercial and trade clubs give out publicity that can point you towards photogenic subjects and hobby clubs near home can put you in touch with their counterparts elsewhere — particularly useful if you have a special

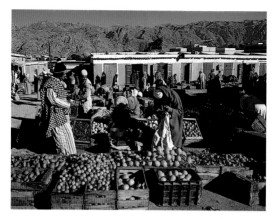

Market Day ▲

Early research reveals the schedule of regular events like markets and sports meets.

Pictures Under Cover ▶

Allow for bad weather by planning some visits where you can take pictures indoors.

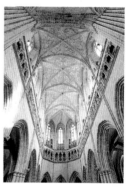

◀ Visiting Wine Country

Before going, contact wine industry offices to find out which wineries welcome visits.

interest such as bird-watching, or live steam railways.

Having established sources and collected information, it is an excellent idea to make a list of places and subjects that you want to be sure of photographing. If your photography is for other than personal enjoyment — you want to produce a slide show for others who share your interests — then it's worth refining the list of locations as far as specific pictures. Make a photographic itinerary that is as flexible as possible, because pictures rarely happen on cue. Some subjects are predictable, but there will certainly be other times when you want to dash off somewhere at short notice.

CUSTOMS AND SECURITY

Crossing a frontier always involves a certain amount of tedious formality: forms to be filled, questions to be answered, and luggage to be inspected. However, a few minutes spent on paperwork before leaving can greatly speed the passage through customs and immigration. A little preparation brings other benefits, too: packing film appropriately can help you avoid the potentially damaging effects of security x-rays. And, assembling receipts and other documents prevents awkward questions on the way back from a vacation. Think before leaving about insurance, too — don't wait for disaster to strike before reading the small print on your policy.

Photographic equipment is expensive; in some countries the value of your outfit can exceed the annual wage of a manual laborer. This means that photographers get more than their fair share of attention, both from customs officials and from thieves. Official interest is the easiest to keep at bay. Some countries limit how much the visitor can bring in, and the amount can be surprisingly low. However, rules are often flexible, and the genuine tourist usually gets fairly sympathetic treatment, provided everything is kept above board. If your equipment exceeds the limit even slightly, always declare the excess: resist the temptation to slip through, as you risk a spot check and possible confiscation of the camera and lenses, or perhaps a heavy fine.

Be Prepared

Before leaving, make a list of everything you are taking with you, noting serial numbers and value. Include receipts if you have them, and take photocopies of all these documents — one for each border crossing that you will make. Not only will this save time on the outbound journey, but if the list is stamped at your point of departure, you won't risk paying import duty on the way home.

Insurance

Elementary precautions such as always locking doors can make theft less likely, but nothing will discourage a really determined thief. Therefore, always insure cameras and lenses before leaving. Special photographic insurance is very costly, so try extending a home-contents policy, or take out tourist travel coverage. This is invariably less expensive from a broker than from a "last-chance" booth at the airport. Read the exclusion clauses closely to make sure that photographic apparatus is properly covered. You may have to make a special list of valuable items.

If the worst happens, always tell the local police, and get their written confirmation that you have reported the theft. This will avoid any argument when you come to make a claim.

A Sea Crossing

Airports, docks and quaysides are often picked out in bright colors and bold shapes, so keep your camera handy when starting and finishing your journey.

Film and x-rays

All film is sensitive to x-rays, and the faster the film, the greater the sensitivity. Many airport x-ray machines carry notices suggesting that the low dosage x-rays used for inspection will not harm film, but this is really only half the story. **One** dose of low energy x-rays may do no harm, but the baggage of many air passengers is subject to more than one inspection, especially now that bags get x-rayed on domestic as well as international flights.

The only real protection against x-rays is prevention. Keep your film in its original cartons, and pack these in a clear plastic bag. Then ask for a hand search at the airport: a courteous request usually gets an equally courteous reply.

Remember, though, that hard-pressed officials will be reluctant to give anybody special treatment if there's a long line of impatient passengers, so maximize the chances of cooperation by checking in half an hour early.

CHOOSING A VIEWPOINT

Think how different something looks from the window of a plane: airport terminals that seem vast on the ground shrink to toy-like proportions when seen from just a few hundred feet up.

This is an extreme example of how different a subject can look from a radically new viewpoint, but you don't need to take a ride in a plane to change the scale and appearance of the subjects in your pictures. Sometimes just kneeling creates a picture that looks different and original — because most pictures are taken with the camera at eye level, 5 to 6 feet off the ground.

Choice of viewpoint is the single most important control over composition, so don't take the photo from the place where you first got out the camera. Instead try to find a better position: it's a rare picture that can't be improved by moving around the subject.

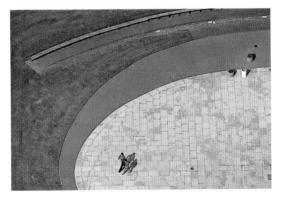

From Tall Buildings

From above, quite ordinary scenes look exciting.

Nearer or Farther

Moving closer to a subject, or farther from it, affects the apparent scale of objects at different distances from the camera. This is because taking a step forward has virtually no effect on the size in the viewfinder of distant detail. Yet that one step forward may cut in half the distance between the camera and a nearby subject — and therefore double its apparent size. Moving closer, then, is a way of emphasizing foreground features. Moving back, needless to say, has the opposite effect. By walking away you can show the sizes of all objects in proportion to each other.

Experiment with Viewpoint

To find out how radically a change of viewpoint can alter your pictures, try taking a range of photos from several different angles.

Left or right

Moving the camera left or right alters the position of different objects in the frame, but keeps their relative sizes the same. For example, if two people stand one behind the other, facing the camera, then the figure in front will hide the one behind. Moving the camera to the left will show the more distant figure to the left of the closer one. Moving the camera to the right reverses their positions — yet the two figures have not moved themselves. You can use this simple technique to reposition the foreground and background in your pictures.

Up or Down

Raising or lowering the camera has a similar effect: up or down movement appears to change the heights of subjects within the frame. From a low viewpoint, foreground subjects appear bigger, and far-off ones, smaller.

From a high viewpoint, everything seems flattened — even a viewpoint of quite a modest height can create an almost aerial quality, revealing patterns and textures that are invisible from lower down.
Often, just a couple of feet of extra height makes a difference. In a crowd, standing on a flight of steps will raise the camera head and shoulders above everyone else, and change the view completely. When you can't find anything to stand on, just hold the camera at arms length above your head, as shown below.

COMPOSITION FOR IMPACT

A painting or drawing begins with a rectangle of paper, on which the artist places colors and shapes to create a pleasing composition. A photographer, though, has to work in the opposite way, placing a frame around the subject to extract the composition from the original scene. For the photographer, the frame is marked out by the edges of the camera's viewfinder — and making effective composition means placing the subject within these borders carefully and selectively.

The simplest way to compose the image is to place the frame tightly around the subject, so as to exclude most or all of the surroundings, and focus attention firmly on the main subject of the picture. Often, though, this approach is neither possible nor desirable. You may, for example, want to include background details to add mood or interest to the image. As soon as there are other things in the picture to distract the viewer's attention, composition becomes less straightforward. Now you must arrange the various subject elements so that there is a clearly identifiable center of interest that draws the eye of anyone looking at the picture. Without this center of interest, the image will lack purpose and direction, and the composition will be unsuccessful.

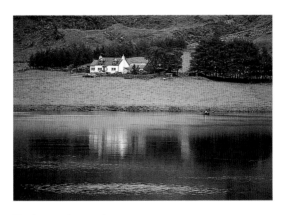

The Center of Attention
Careful composition can make even a small subject dominate the picture.

Where to Place the Subject

The most obvious position for the center of attention — the middle of the frame — is rarely the most eye-appealing. A central subject creates a static and symmetrical image, and additionally makes other details more difficult to include in a balanced way. In most circumstances it is better to frame the subject off-center, so that the focus of interest falls between the corner of the picture and the middle. A good general rule is to imagine that the viewfinder is divided into thirds, and place the subject on one of the four lines that separate the thirds — or at the junction of two lines.

Of course, not all pictures have a clearly identifiable subject. With a portrait, the subject is obvious, but what about a landscape? With a general scene, the center of interest can be a subtle feature of the image, such as a splash of color or a bright highlight. You should always identify this vital focal point first, before deciding how best to frame the picture.

Where to Place the Horizon

Many outdoor travel pictures have an obvious horizon line, and in flat country, the horizon will divide the picture exactly in two when the camera is held horizontally. Like a centered subject, this makes for dull, half-and-half pictures. Try tilting the camera up or down slightly, so that the horizon lies closer to the edge of the frame. If the foreground is specially interesting, point the camera down, so that the horizon lies at the very top of the frame.

When the sky itself is dramatic — in stormy weather, or colored by a sunset — make it the main subject, by pointing the camera up. The land beneath will then form a narrow strip across the bottom of the picture.

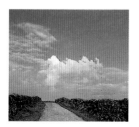

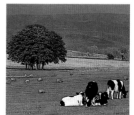

JUDGING THE MOMENT

What makes a photograph unique is that not only is it a good record of the scene in front of the camera, but that it shows how the subject appeared at just one instant in time. This is what gives photographs their sense of immediacy and realism — and explains why traveling with a camera can be so rewarding. Unlike picture postcards, your own photographs show the places you visited at the very moment you were there — down to the last leaf drifting past on the breeze, or the level of the coffee in your cup on the cafe table. Because the camera catches such a specific instant, the moment when you take the picture is especially important.

Judging the moment isn't difficult if you want to catch a horse leaping over a fence or a swimmer between diving board and pool. However, good timing is important for all pictures, not just those where there is a single climax. A white capped breaker crashing on a beach repeats its dramatic performance every few seconds. Yet the photographer who waits and watches 50 waves is more likely to capture a picture of that moment of tension when the tip of the high-piled surf begins to topple downwards. Even serene landscapes look better at some moments than others: banked clouds sometimes part to let a sunbeam briefly illuminate a single field or building.

Catching unforgettable moments demands patience and taking time to wait until all the elements in the scene crystalize into the picture you want. And when everything is perfect, you need quick reactions to snatch the picture before the scene changes.

Perfect Timing

Judging the moment has a less immediate meaning — picking the right time of day. The colors and shadows of the natural environment change as the sun crosses the sky; and though the changes are slow, they can be quite striking if you photograph the same scene hour by hour. In the city, human activity overlays the sun's movement. A street market that is empty at dawn will be throbbing with life at noon, and litter strewn but empty again at nightfall.

Time of day affects indoor pictures, too. At night, windows make gaping black holes in your pictures; and by day, the same windows form burned-out rectangles of light. Catch the room at the end of the day, though, and you can strike a much better balance between inside and the scene outside.

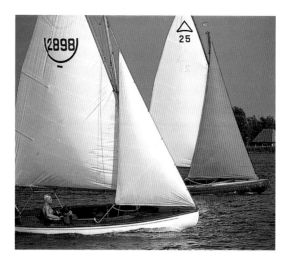

Racing Sails

At sports events, be patient and wait for moments that really catch the excitement of neck-and-neck races.

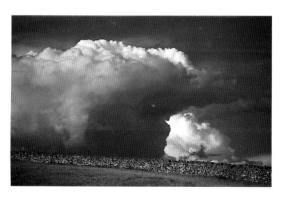

After a Storm

Hurry out as soon as the rain stops, and catch dramatic cloudscapes and brilliant shafts of sunlight. These photogenic conditions don't last long, and the weather may soon be just dull and gray once more.

FAMILIAR LANDMARKS

Every city has at least one landmark that is instantly recognizable. The Eiffel Tower could only be in Paris; the Empire State Building unmistakably identifies New York City; and a glimpse of the Golden Gate Bridge tells you that you're in San Francisco.

"Instant recognition" is both a blessing and a curse. These famous landmarks appear so often on postcards, and as scene-setters in movies, that it can be difficult to take pictures of them that are not simply tourist "clichés". On the other hand, precisely because the locations are so familiar, you can photograph them in unusual or innovative ways, and people will still be able to tell where you were when you took the picture.

Before taking your own pictures of such places, it's worth looking at postcards and guidebook pictures of them. Not so that you can take the same conventional picture, but because the people who made these photographs took a lot of time getting them right. They waited for good weather and found the viewpoint from which the landmark was most clearly visible. By looking at what people have already done, you can get a head start. You may want to avoid the popular viewpoints. Or perhaps, by looking at existing images, you'll think of how you can make a more original view from the same spot. Either way, here are some ideas that can help you escape from the postcard syndrome.

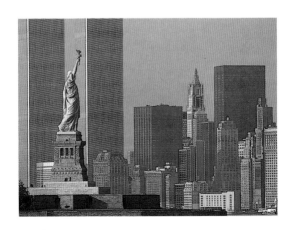

The Unusual View

Don't feel you have to show the whole landmark. Just one leg of the Eiffel Tower, for example, is quite enough to identify the place. The people who look at your pictures will fill in the rest from their own experience, or from pictures that they've seen before. Sometimes you don't even have to show the landmark at all: a characteristically shaped shadow or reflection sets the scene as in the picture below.

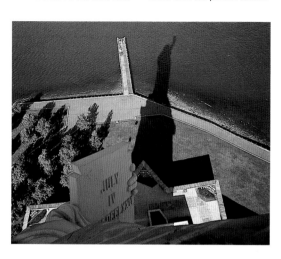

Don't Mind the Weather

How many photographs are there of the St. Louis arch in pelting rain? Or Buckingham Palace peeping through London fog? Bad weather provides an opportunity for you to break away from the conventional.

◄Use Different Lenses.

A wide angle lens makes the subject loom dramatically overhead. A long telephoto lens may enable you to picture the place from a distance of a mile or more, from a viewpoint that nobody else has thought of.

Don't Hide The Crowds

Most landmarks are thronged by tourists, yet postcard views taken at six o'clock on a summer morning present an unnaturally empty picture. You may even want to make the masses of faces a prominent feature of your personal view.

Make several visits.

At different times of day, you'll get a range of different views. Dusk and dawn can be particularly effective, because at these times the fading daylight mixes with the warm glow of electric lamps.

MODERN ARCHITECTURE

Who hasn't gazed up at the steel, concrete and glass of modern buildings, and been inspired to capture the soaring skyscrapers on film? Compared with the ornate, stylized lines of classical buildings, modern constructions are sometimes a refreshing change, and offer quite different challenges to the photographer.

Remarkably, traveling reveals more clearly than ever the differences of approach that usually pass unnoticed at home. Far from being anonymous boxes, many modern buildings bear marks of the architect's hand that are as plain to read as those on any Gothic cathedral.

Modern architecture invites a vigorous and extravagant handling of the camera. Don't be afraid of pointing it steeply upwards — converging vertical lines might spoil a picture of an old building; but they can make a new one look as if it's clawing at the clouds.

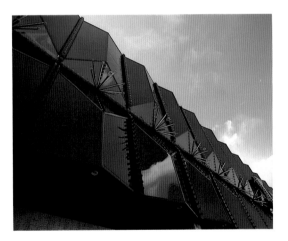

Look for Detail

Don't overlook the possibilities that building details offer. Modern architecture usually has strong elements of regular pattern and rich texture, and you can make lots of unusual and exciting images by narrowing your sights a little. Do this by moving closer or, even better, by using a telephoto lens. From a distant viewpoint, a telephoto compresses perspective, creating a flatter, more graphic photograph.

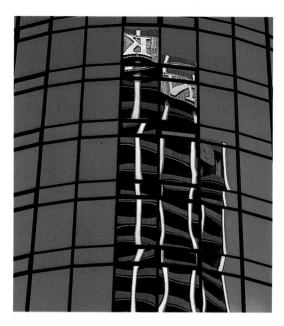

Mirrors for Walls

Pointing the camera up frames a building with sky, so pay special attention to the weather. Stormy weather adds drama even to an unexceptional modern building, but blue sky generally makes a more attractive photograph. Make the sky bluer still on color film, using a polarizing filter — underexpose slightly to make hues even richer. If you're using black-and-white film, select a yellow filter to darken the blue sky and lighten clouds, or a red filter to turn the sky almost black. If the sky is dull and gray, or just very pale blue, try adding color to the top of the image using a graduated filter.

A very striking feature of many modern buildings is the use of mirrored glass. Pointing the camera at the shiny silver or gold surface, you can photograph not only the building itself, but the world around it, too. A close, low viewpoint carries reflections of the sky right down the facade; whereas a more distant camera position echoes the surrounding buildings — a particularly effective approach when the buildings are very old. The strength of the reflection depends on lighting: the boldest effect occurs when the mirrored building is shaded, and the one reflected is sunlit.

OLD BUILDINGS

Old buildings whisk you back in time: step inside, and centuries slip away. Here's how our grandparents' grandparents lived; and there's a place of worship that has changed little in 10 or 20 generations. Capturing the immense history of these traditional buildings means focusing on the past and playing down the present, and this isn't always easy.

The simplest way to recapture the authentic flavor of antiquity is to move in close and crop out the 20th century. However, if space is really limited, and it's impossible to get a complete view of your subject without including modern elements at the edges of the frame, then try picturing just a part of the facade, as in the image below.

Fortified places had a special function: they had to keep out unwanted visitors, so they were built very carefully. The strength and weight of these structures guaranteed their long life, and you'll often find fortifications still standing even when the buildings they protected crumbled centuries ago. It's always worth making a detour to visit such castles and ruins, not just to photograph the structures themselves, but because the original inhabitants built in places where they could observe the land for miles around — so you'll get good distant views, too.

Bringing Out the Age

Not only have the overall shapes of buildings changed through the years, but the materials and methods of construction have altered, too. Once you have an attractive picture of the building as a whole, why not try and capture on film the beauty of traditional design? Old buildings often are much more heavily decorated than modern ones — carved wood and stone abound. To bring out the texture of a shallow relief picture, wait until sunlight shines obliquely across the surface.

City Color

Look out for splashes of bright color to contrast with the drab hues of old stone and brick walls.

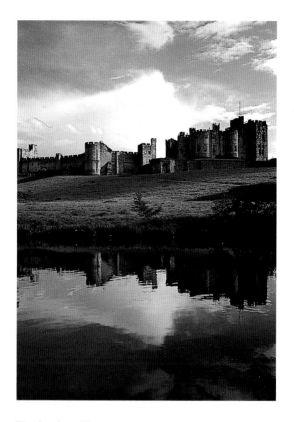

The view from Afar

Sometimes distant views of old buildings are more impressive than close-ups. Their architects wanted to create imposing structures, so they built tall, and they built on the highest ground they could find.

Stand at the foot of the building with a map and scan the horizon for possible vantage points. Ignore very distant hills, because haze will almost certainly obscure the view, particularly in the city. Having traveled to the points you identified, look back at your subject. You'll often find that the building looks imposing even through the viewfinder of a simple camera, or with the normal lens of an SLR. And from this far-off viewpoint, you'll often make an effective contrast between ancient and modern.

PICTURES INDOORS

Quite often the interior of a building is even more imposing and interesting than the exterior — what's more, you can comfortably take pictures inside, when it's raining or dull outside. However, before you use your camera in a public building, you should first make sure that photography is permitted. You may have to pay a fee or make a contribution to the upkeep of an old building, and there may be restrictions, perhaps on the use of tripods or flash.

Even in apparently quite bright conditions, dim light makes photography difficult. Our eyes soon adapt, and we don't notice the gloom. But unfortunately, film does not compensate for low light levels in the same way. Flash units are rarely powerful enough to illuminate any but the smallest rooms and generally it's better to rely on fast film, wide apertures, and long exposures — all of which can help you deal with the dim lighting.

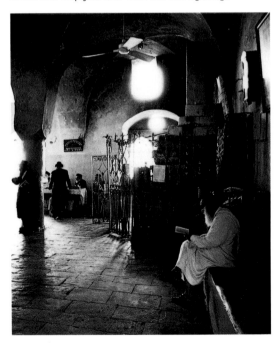

Stained Glass

Stained glass windows fill old churches with rich color, but to record their full beauty in a photo, you must pay special attention to exposure. Unless the window fills the frame, your camera's meter will be misled by the dark church interior. To prevent this, move close to the window to take a meter reading, then move back to recompose the picture.

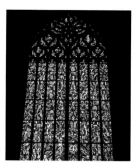

Contrast and Color

Indoors, windows are many times brighter than other parts of the room, creating contrasts that are far too high for film to cope with. Turn your back to the windows whenever possible, to reduce the high brightness range.

Watch the color of the light, too. Light bulbs throw out a yellow glow, creating a warm cast on color slides. A blue 80A filter can reduce this. Similarly, fluorescent tubes make pictures look green — use an FLD or 30M filter to correct the color balance. Neither color cast is as serious on negative film, but using the correct filter will always improve your pictures. Whenever possible, avoid mixing two types of light — such as sunshine and light bulbs.

Using Window Light

The extremes of light and shade created by windows can sometimes work to your advantage. Here shooting towards the windows has hidden the fussier details of the interior, making bold patterns of light and dark.

Coping with Dim Interiors

Few travelers are prepared to burden themselves with tripods, but in dark interiors, these three-legged friends are invaluable. Even a folding pocket tripod is better than none at all when light is low. Nevertheless, if you've set your lens to its widest aperture, and your meter indicates that you must use a shutter speed that is too slow to handhold, there are still things you can do — even without a tripod.

First, check film speed, and change to a faster film if you have one. Second, if you are using one of the KODAK EKTACHROME Films for color slides, reset the camera's film-speed dial to double the ISO value of the film. When you send the film for processing, ask for "push processing" for two times normal film speed. Note, though, that every picture on the roll must be exposed at the same film speed. If you find that you still can't hand-hold the camera, try propping it up or resting on a seat, the camera will shake less than in your hands. If your camera has a self timer, use it to operate the shutter.

SHOPS AND MARKETS

To get a taste of the true characters of the region you are visiting, head for the local shops and markets. Produce markets rarely attract tourists, so they generally have a very local flavor. They are ideal hunting grounds for character portraits: stall-holders the world over are born performers, and will shout and yell to advertise their wares if they think there's the least chance of getting a sale.

Don't stick to produce markets, though, because regular shops and flea markets can provide equally spectacular subjects for your camera. Shops reveal a great deal about a place and its life-style, both through the goods that are bought and sold, and through the way the transaction is completed. What could be more unusual than the electronic efficiency of shopping in a western city, and the barter and haggle of an eastern bazaar?

Even store fronts can provide interesting and effective compositions, with their bold colors and flamboyant lettering. You might want to make this the theme for a series of pictures; such a collection illustrates the diversity of shops in different places, yet also reveals the rarely noticed details that are common to all places of trade.

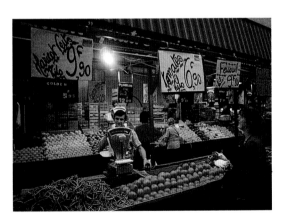

Brightly Lit Stalls

When they merely contribute to the existing daylight — as in this picture — light bulbs add warmth and color. But after dark, use an 80A filter to improve colors.

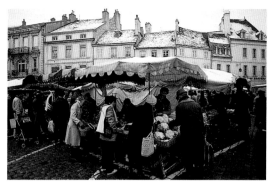

Overcast Weather

The sun hides stalls in shadow, but on dull days you'll catch more detail under the awnings.

Closing In

Don't overlook the colorful heaps of produce piled high.

The best time to take pictures of outdoor trading is early in the day. Most markets start at the crack of dawn; later in the day, the neatly arranged pyramids of fruit and other produce shrink to untidy heaps. The lighting is better early, as well. Low sunlight catches the faces of traders under their awnings, and shadows are not as heavy as when the sun is higher in the sky. Around midday, contrasts are much higher in bright sun, casting deep shadows across the stalls. If you are obliged to take pictures around noon, alleviate the problem by using fill-in flash (see page 70-1) or photograph subjects in open shade, which softens shadows and reduces contrast.

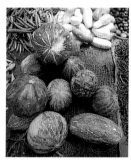

What to Take

Simple cameras work especially well in markets. They generally have moderately wide-angle lenses, which are always an advantage when there are crowds around, limiting space. Try moving quite close to a stall: the goods for sale will then dominate the foreground of your picture, with the trader appearing at the top or one side of the frame. Check that you're using quite a small aperture, so that there's enough depth of field to keep everything absolutely sharp.

TOWNSCAPES AND CITYVIEWS

In the countryside, landscape pictures are those that usually show the whole environment, rather than closing in on a single plant or a small rural detail. Similarly, in a built-up area, you can take urban landscapes that don't just feature a single structure, but the way buildings blend and merge — or perhaps how they contrast and clash. Urban landscape photos can make social comment, too, showing how modern architecture edges out traditional buildings, or highlighting the relationship between the built-up environment and the people who live and work there.

Most important, though, town and city views make dynamic, interesting, and often surprisingly colorful pictures. And in a travel album or slide show, an urban landscape makes a great at-a-glance scene-setting picture that will leave your audience ready and waiting for a closer look.

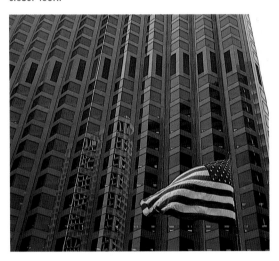

Foreground Interest

Details close to the camera add a sense of depth, scale and identity to urban landscapes. Look for street signs, kiosks, and traffic that you can juxtapose with the distant view for variety and impact. These foreground objects don't have to be sharply focused — a blurred stoplight or neon sign can be just as colorful as a sharp one.

Lenses and Perspective

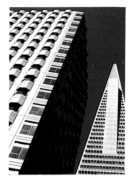

You can make good use of the effects of perspective in this kind of picture. Wide-angle lenses help create strong lines within an image — along a receding street, for example. Conversely, a telephoto lens produces a more compressed effect in which details that are actually far apart seem quite close together. Thus telephoto lenses produce images with less feeling of depth and distance, but accentuate shapes and patterns within the subject.

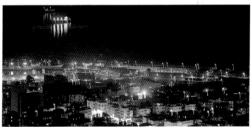

Bird's-eye Views

Most cities have at least one tall building in which there is public access to an upper floor, and this will usually give you spectacular aerial views of the scene below. Many observation floors are now glass-enclosed, though, so you should take special care to see that the glass does not spoil your photos. Use a wide-angle or normal lens, because telephotos exaggerate surface imperfections. Choose a clean area, and to minimize reflections, press the lens close to the glass. A rubber lens shade is useful here, as it shields the lens and provides a cushion against vibration. If you don't have one, cover the camera and your head with a dark coat to cut out light from behind.

Pick your timing carefully for best results. Even on an apparently clear day, haze often spoils distant views, though a UV or polarizing filter can sometimes cut this down. The best time of day is early morning. And cold, crisp weather is better than summer's humid closeness. For a really spectacular effect, climb to these aeries at dusk, and photograph the surroundings as the lights come on. You may even be able to watch and photograph the sunset twice — once from ground level, and again from up high!

STREET LIFE

Travel can be an eye-opener, making us more aware of the people around us, and of the many ways in which the pattern of their everyday lives differs from our own. Relaxing on vacation, we have time to sit back and take in the expressive gestures that people use in conversation. We also can observe from a distance the familiar tasks of daily existence performed in new, exotic or just plain different ways.

This heightened awareness of others can improve our people pictures: street scenes that would merit just a glance at home now seem enthralling. And somehow, raising a camera to the eye seems a more natural process in unfamiliar surroundings.

Pictures snatched on the spur of the moment are invariably fresh and spontaneous; but often, you can get better street images by talking to the people you meet, and asking them if you can take a picture. This produces eye-to-eye contact that makes the finished photographs more direct and immediate. If you have the nerve, try both approaches — take candid pictures until your subjects notice you; then chat with them and catch their response when they're aware of the camera.

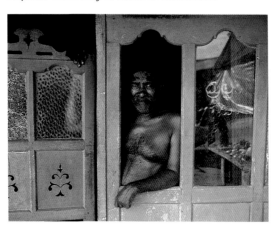

Street Faces

Don't move too close; keep your distance, and surrounding details will add interest and color to your portraits as in this Indian street scene.

Gaining People's Confidence

You can often win over even quite reluctant subjects with the promise of a print — but don't forget to send it.

A perceptive eye and a quick response are the main requirements for good street pictures: the equipment is of secondary importance. In fact, traveling light is a positive advantage, because there's less hardware to get between you and your subject. Set your camera meter to **auto**, to minimize fiddling with controls, but keep an eye on the apertures and shutter speeds that your camera indicates. With slow film or in dull weather, the shutter speed can easily drop to a setting that's too slow to hand-hold.

Raising a camera to the eye is an action that always attracts attention, so it's a good idea to preset the focusing control by guesswork before doing this. Then you can make minor adjustments very rapidly in the instant before pressing the shutter release. Or simply set the lens to a small aperture and rely on extended depth of field to take care of any focusing errors. A few photographers even dispense with precise framing, and "shoot from the hip" when they want to remain completely unnoticed, but this requires plenty of practice — and lots of film.

Film Choice

Black-and-white film is a good choice for "slice-of-life" pictures, because color can sometimes seem like a distraction. A monochrome print somehow conveys a better sense of immediacy and gritty realism. Choose fast film rather than slow; even in dull weather, an ISO 400, 800 or 1000 film allows you to set fast shutter speeds and small apertures, so that subject movement, camera shake and focusing errors are less critical.

ISOLATING DETAILS

Starting with even the simplest of subjects, there is the potential for thousands of pictures. All that is needed is a perceptive eye to frame the subjects in the camera's viewfinder. Moving closer makes the framing tighter, and isolates within the straight edges of the photograph small details that are perhaps not immediately recognizable as parts of the subject as a whole.

Narrowing the field of view in this way reveals beautiful "hidden pictures" — even in unlikely places. The key to this abstracted approach is to disregard the subject matter altogether, and think constantly of the photograph's flat surface, rather than the three dimensions of what's in front of the camera. Then consider the picture in terms of its five visual elements — shape, pattern, color, texture and form.

Shape

Shape shows up best in silhouette. With light coming from behind, a subject's shape or outline stands out bold and clear. Bring out shape by positioning potential subjects against bright backgrounds — preferably the background should be three or four stops brighter than the subject. Take a meter reading from the background, not the subject, when setting exposure. Remember that shape varies with viewpoint. A silhouette of someone facing the camera is anonymous; but the shape of the same person's face in profile often is immediately recognizable.

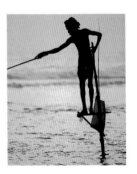

Form

Form is another word for a subject's roundness and volume. To emphasize form, use oblique light — but not the harsh sidelighting that is so good for showing texture. Instead, look for more gentle illumination such as the soft light from a chintz-covered window.

Pattern

Patterns can be orderly or random. Orderly stacks of bricks, logs, or fruit look attractive because our eyes fix on the same motif endlessly repeated. Disorderly patterns like scattered, rusting pieces of scrap metal fascinate us because we look for order and organization — and don't find either one. Pattern pictures of both types work best when there is some element to catch and hold the eye — like an apple in a pile of oranges, or a bit of shiny chrome among the rusting metal.

Color

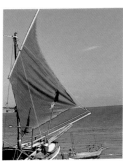

To make color the subject, you don't need a riot of many hues. The best pictures often employ just one or two colors, as at left. Look for colors that harmonize — like yellow and orange; or for a more vigorous image, choose contrasting hues such as red and green. You can accent colors with slide film by underexposing half a stop. With both slide and negative films, a polarizing filter often helps increase color saturation.

Texture

Bring out surface texture with hard crosslighting. Raking light exaggerates every surface detail, making pictures that you'll want to reach out and touch with your fingers. Early morning and late afternoon are good times to make texture pictures, because the low sun glances obliquely across the landscape. In dull weather, or in soft light indoors, use sidelight from an electronic flash unit to bring out the surface roughness.

OUTDOORS AFTER DARK

Don't put your camera away when the sun sets — you can take pictures right through the night if you use fast film and change your technique a little. In the city, streetlights, autos and store windows throw out lots of light, and in the country, you can perch your camera on a rock and lock the shutter open. In a few minutes you'll have collected ample moonlight to make a good picture.

With fast film, you can get good night time pictures at shutter speeds of a second or shorter, and if you have an aperture-priority automatic camera, it may well be capable of giving exposures much longer than those marked on the shutter speed dial. To find out, just set up the camera in a dark place, press the shutter release, and count seconds. Check with the instruction book first, though, to make sure this won't drain the batteries. To make the most of the night, however, you need a camera that has a B setting on the shutter dial. This setting leaves the shutter open as long as the release button is held down. To prevent vibration, you'll need a locking cable release, too. A tripod helps, but you can generally prop the camera up somewhere if you can't be bothered to carry a tripod.

Film and Exposure

Use fast film — ISO 400 or faster — unless you have a tripod. Slower films give better colors, but may prolong exposures to patience-trying lengths. Color negative film demands less precision in setting exposure than does color slide film, but with negatives, it's a good idea to tell the processing lab which rolls the night pictures are on. Otherwise the lab may think the negatives are failures, and not print them. Don't bother with filtration for general night scenes: usually the color casts look quite pretty.

To set the camera's controls, base exposure estimates on the chart opposite. Then bracket the pictures by giving one or two stops over and under the setting recommended.

Look for Reflections

Pools and wet streets mirror night lights, and double the impact of your pictures.

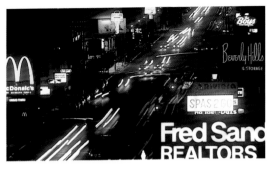

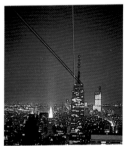

Don't Use Your Meter

Exposure meters are easily misled by the great contrasts of light and dark, so set exposure using the table below.

Compose Carefully

Try to exclude from your pictures any large areas of shadow, as these will appear black and featureless on film.

Subject	ISO 64-100	ISO 125-200	ISO 320-400	ISO 800-1600
Brightly-lighted street	1/30, f/2	1/30, f/2.8	1/60, f/2.8	1/60, f/4
Bright theatre district	1/30, f/2.8	1/30, f/4	1/60, f/4	1/125, f/4
Neon and other signs	1/30, f/4	1/60, f/4	1/125, f/4	1/125, f/5.6
Store windows	1/30, f/2.8	1/30, f/4	1/60, f/4	1/60, f/5.6
Subjects by streetlight	1/4, f/2	1/8, f/2	1/15, f/2	1/30, f/2
Floodlighted buildings	1 sec, f/4	1/2, f/4	1/15, f/2	1/30, f/2
City skyline at dusk	1/30, f/4	1/60, f/4	1/60, f/5.6	1/125, f/5.6
Moving autos, light trails	20 sec f/16	10 sec f/16	10 sec f/22	10 sec f/32
Fairs, amusement parks (rides – light trails)	1/15, f/2 / 4 sec f/16	1/30, f/2 / 2 sec f/16	1/30, f/2.8 / 1 sec f/16	1/60, f/2.8 / 1 sec f/22
Fireworks – shutter on B	f/8	f/11	f/16	f/22
Lightning – shutter on B	f/5.6	f/8	f/11	f/16
Burning buildings, fires	1/30, f/2.8	1/30, f/4	1/60, f/4	1/60, f/5.6
Subjects by fires	1/8, f/2	1/15, f/2	1/30, f/2	1/30, f/2.8
Floodlighted sports (events)	1/30, f/2.8	1/60, f/2.8	1/125, f/2.8	1/250, f/2.8
Moonlighted landscapes (snow-covered)	30 sec f/2 / 15 sec f/2	15 sec f/2 / 8 sec f/2	8 sec f/2 / 4 sec f/2	4 sec f/2 / 4 sec f/2.8

INDUSTRY AND AGRICULTURE

Farming and manufacturing may not seem the most obvious themes for the globe-trotting photographer. Yet potentially they offer picture opportunities more colorful, graphic, and richly varied than practically any other subject. Small, local differences produce dramatic changes: travel just a few miles, and pastureland dotted with lazy cows gives way to rolling acres of golden sunflowers. A sudden change in the rocks beneath your feet creates an equally sudden alteration in the skyline above — and towering steel mills give way to deeply gouged quarries.

As the pictures on these pages show, all these aspects of industry and agriculture can provide "fodder" for the camera — but only if you are prepared to look beyond the obviously picturesque.

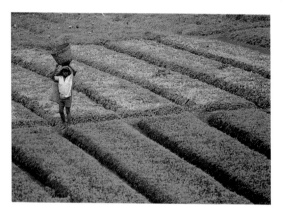

Work on the Land

Farming activities have considerable influence on the nature and appearance of the landscape. The vine-covered hillsides of a wine region look totally different from the vast tracts of land given over to crops such as wheat or corn. These patterns of cultivation give scenic pictures a strong element of color and pattern, particularly if you can isolate small areas of a distant scene using a telephoto lens.

Farm work makes an ideal center of interest in landscape pictures, an creates a sense of scale that might otherwise be missing. A human figure — even when tiny — will attract a viewer's attention and become the focal point of a composition.

Farming the Waves

In coastal areas, fishing is a rewarding subject for the camera — and certainly more superficially attractive than heavy industry.

The trappings of the fishing industry are often very colorful — look for brilliant plastic floats and heaps of nylon netting. Small fishing boats at anchor are also traditional subjects for photography. Try to look beyond these obvious sides of fishing, though, if you want unusual pictures. Find out when the catch will be landed, and be on the spot to capture the flailing fins and silvery scales flashing in the sun. If you are lucky enough

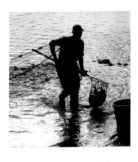

to hitch a ride on a working fishing boat, you'll get pictures of the day-to-day reality of the fishing industry — hard work, cold and discomfort — rather than the conventional romantic view.

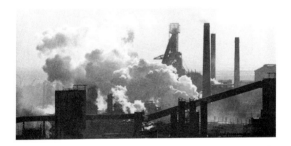

Industrial Drama

In industrial areas, look for symbols of power — or simply emphasize the drama of the scene. Steel and coal towns in particular have characteristically jagged skylines that look bold and graphic in silhouette. And oil refineries make a lace-like tracery of pipes and supporting gantries when seen against the sky.

Choose black-and-white film for drama and no-nonsense realism and use a yellow or red filter to lighten clouds in the sky behind. With color film, wait for a blue sky, or a richly colored sunset. These will provide a vivid backdrop for the strident shapes. In dull weather, attach a deep color filter to the lens to pep up the scene.

Always expose for the sky behind, and not the building, if you want to create a silhouette effect.

EVENTS AND TRADITIONS

Local festivals make colorful subjects for the camera, and it may be worth altering travel plans slightly to take in an annual parade or celebration. The origins and purpose of many of these are lost in antiquity, and all that remains is the rich pageantry and spectacle.

If you can, make an effort the day before the event to inquire about the location and timetable for the proceedings. Then you can get to the best viewpoints before the inevitable crowd of onlookers and revellers hems you in.

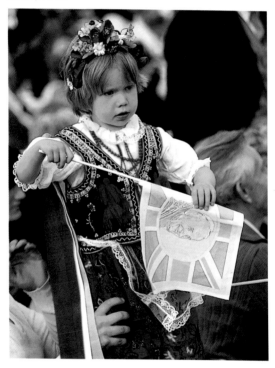

Don't Forget the Crowd

Often people lining the street are as bright and colorful as the event they are watching.

Use a telephoto lens to pick out individuals nearby, or turn the camera to catch a sea of attentive faces.

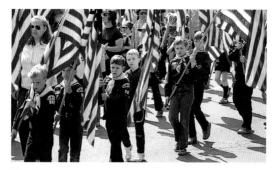

Flags Flying

A flag, banner or pennant brightens up even a dull parade. But massed together in dozens, flapping flags look even better. Save your film until flags fill the picture

Religious Festivals

The tourist board of your destination country can usually supply information about local festivals such as this religious feast day in Italy. Take care, though, to respect local customs and etiquette. The monks and nuns in this picture did not object to being photographed, but in some cultures, taking pictures of such a scene might be considered offensive.

INFORMAL PORTRAITS

Taking portraits is an important part of vacation and travel photography, whether the subject is a companion, someone you meet, or just a stranger with an interesting face. These pictures are usually taken quite quickly in passing, but with careful technique, you can add considerably both to the quality of the photograph and the pleasure it brings.

A Relaxed Pose

The key to a good portrait is to make sure that your subject is comfortable and relaxed. This will avoid the tense, self-conscious quality that spoils many pictures of this type. If possible, find somewhere for your subject to sit down, or failing this, a fence, gate, or wall for them to lean against. Most people feel awkward about their hands and arms when they are standing up. A sitting or leaning pose gives them something more to do.

Don't simply ask your model to look into the camera; try for some natural reaction by carrying on a conversation or telling a joke. Even if language is a barrier, it's better to attempt some exchange of words, rather than let a self-conscious silence develop while you take the pictures.

Lighting

Strong directional lighting, such as direct sunlight, creates excessive contrast and heavy shadows. On a sunny day, it is better to take pictures in the shade than in full sun. Move into the shadow of a tree or a building as shown above, or alternatively, turn your subjects away from the light so that their faces will be in shadow. Don't forget that you will need to compensate for a bright background by giving more exposure than your meter indicates. Do this either by taking a meter reading in the normal way, then allowing an extra 1 ¾ to 2 stops; or by moving closer to the person's face to take a meter reading, and then moving back to take the picture. On an automatic camera, there may be a **backlight** button for exactly this situation. Pressing this button gives a fixed amount of extra exposure.

Flash in Daylight

In bright sunlight, or when subjects are strongly backlit, use flash to soften harsh shadows. Set the exposure as follows.

1 Set the flash unit to double the ISO value of the film in the camera.
2 Choose the smallest aperture option from the flash calculator dial, checking that the subject is within flash range. Set the aperture on the camera.
3 Meter the scene normally, taking care that the shutter is set no faster than the flash synchronization speed.
4 Take the picture.

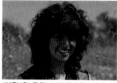

WITHOUT FILL-IN FLASH

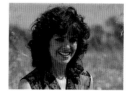

WITH FILL-IN FLASH

PEOPLE AT WORK

Hardly anyone notices a camera when they are engrossed in a task, so the expressions of people at work are generally natural and unguarded. Such pictures have additional impact, too, because the job that the subject is performing can itself be a source of interest — and the photograph becomes something more than an ordinary portrait.

Look out for exciting or unusual sorts of work as you travel: traditional arts and crafts make popular subjects and provide a nostalgic reminder of a time when the pace of life was slower than it is today. Don't neglect modern jobs, though. A photograph of a single worker at the controls of a large machine can make just as powerful an image as that of a potter or blacksmith.

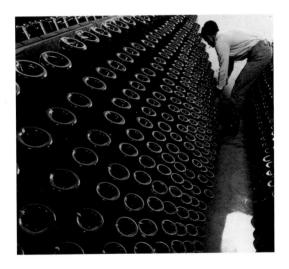

Show the Work Environment

The atmosphere in which someone works usually gives a clue to what they are doing. Include tools, tool racks and raw materials in the background to help tell the story. If you have one, a wide-angle lens will help you to do this; but otherwise, look for viewpoints that give a broader picture. Stand on a chair; take pictures through an open window or door; or frame the reflection in a mirror if you cannot get far enough back.

Expressing the Task

If you want your picture to show clearly what someone is doing, you'll need to take special care. Most jobs consist of a series of smaller tasks performed in sequence, and isolating just one action may give a false picture of what the job as a whole entails. Wait and watch for a while, and try to identify one activity that sums up all the others.

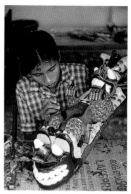

Close in on Hands and Face

To make powerful pictures, you need not show both the workers and the tasks they are performing. Tightly cropped faces draw attention to the concentration and effort that a job demands. Hands, too, testify to a lifetime's labor. A typist's hands, for example are textured quite differently from those of a manual laborer. Move in close to your subjects to capture the character in their palms and fingers.

ACTION PICTURES

Catching action with a camera isn't just a matter of knowing when to press the shutter release, but if you can get this right, you're half way there. Additionally, you need to know how to use the camera's shutter to control how your subject appears on film. Fast speeds will freeze most motion; slow ones spread action out into a silky blur.

Direction of movement also affects how action looks in a photograph: at slow shutter speeds, subjects moving towards the camera appear sharper and better defined than those crossing the field of view. Even with slow-moving subjects, some parts move more quickly than others, the feet of a pedestrian may appear blurred at shutter speeds that are fast enough to freeze face and body.

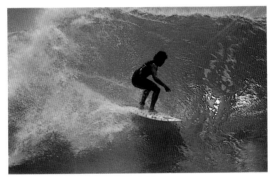

Which Shutter Speed

To freeze action, use the fastest shutter speed you can — for the picture above, bright sunlight enabled the photographer to set a speed of 1/1000 second. However, often dim light prevents fast shutter speeds. As a guide, these are the slowest shutter speeds that will freeze movement: for subjects moving at walking pace, use 1/125; for running pace, 1/500, and for vehicles, 1/1000 second. Speed is not the only factor, though, the faster your subject crosses the frame, the faster shutter speed you must use. So far subjects moving across the field of view, those close to the camera, or those seen through a telephoto lens, use speeds one or two settings faster than those guides. And conversely, when the direction of motion is towards or away from the camera; or when the subject is far off or seen through a wide angle lens, you may be able to use one setting slower.

Panning the Camera

When the action is crossing the field of view, you can capture a powerful sense of movement by panning the camera — swinging it during the exposure to follow the subject. The technique works well with even the simplest camera.

If possible, find a camera position where the subject crosses a dark background. Don't stand too close, or you may find framing difficult — and run the risk of getting knocked over! Prefocus the camera on a point where the subject will pass through. Frame the subject as it approaches; then follow through, releasing the shutter just at the moment when the action is closest. Practice and experiment will perfect your panning technique. Try using slow shutter speeds, such as 1/30 or 1/15 second, to turn the background into horizontal streaks of color, while maintaining the shape of the subject.

Be Prepared

If you know exactly where your subject is going to appear, you can preset all the camera's controls. If the subject is moving towards the camera, press the shutter release shortly **before** the picture is absolutely sharp, because there is always a brief delay before the shutter opens.

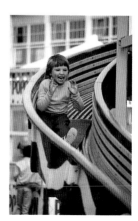

TAKING A CLOSER LOOK

At their best, travel pictures are "magic carpets" — they transport the viewer back to the spot where the photographer stood and pressed the shutter release. The pictures that have this effect don't always show famous landmarks or traditional tourist scenes. More often, they focus the attention on small details that distinguish or characterize a particular region: landscape features; people's dress; signs and notices; regional food; or ramshackle local transport. A series of carefully selected glimpses of this kind can give a more revealing and evocative insight than the broader view and the general picture.

Most pictures are viewed individually: only in books and magazines it is common to see a group of pictures relating to a single theme. This multi-image approach has advantages, though, if you want to sum up the atmosphere of the places you visit. You can use images that might on their own be too abstract or ambiguous, but

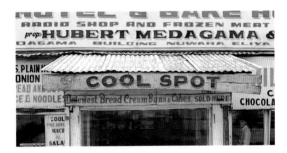

which fall into place when you put them together with others on the same theme. And by concentrating on just one topic at a time, your picture-taking does not become aimless and uninspired.

Photo Assignment

Set yourself specific objectives and guidelines — just as if you were on assignment for a picture magazine. Aim to make a specific number of pictures — perhaps 10 or 12 — that give an in-depth view of a particular place or activity. The subject could be a town, or perhaps a market in that town as in these pictures. It might be a local product such as cheese or wine, and how it is made. Or your theme might be a special event, like a bazaar or festival.

Use different viewpoints and lenses to change the pace and format of your pictures, and mix descriptive photographs with those that are dominated by pattern, shape or color. Bear in mind that the photographs have to form an integrated whole, so they have to work together harmoniously: there's no place for prima donnas in a chorus line.

To present your photo essay, frame the images under glass, or arrange them on a single album page.

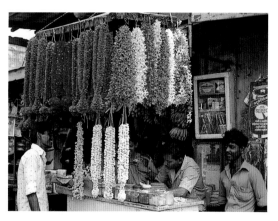

RECORDING A VACATION

A vacation is the high point of the year for most people — a break from daily routine, and a source of happy memories in the years that follow. Often, though, vacation pictures don't do justice to the reality. Instead, they are just a random collection of images that have meaning only to the photographer and those who appear in the pictures.

Think of your vacation pictures like scenes in a silent movie. When you show your album or slides to friends, will they be able to follow the action? One way to make sure that they do is to write a short list of the crucial events that are milestones of any trip, and make a point of recording these events on film. Actually sitting down and thinking up such a list will quickly reveal potential subjects that you would otherwise overlook. For example, packing baggage and checking in at the airport are unlikely events to record with a camera, but they make valuable scene-setting pictures that give continuity to a vacation story. Between these descriptive pictures, you can intersperse the unplanned, spontaneous photographs that you would normally take while away. Try to make these as varied as possible. Alter the scale by mixing close-ups with distance shots and general views. When photographing people, don't just take the usual portraits. Instead, you could get close to fill the frame with just the eyes. Then move back so that the figure is just a tiny silhouette on the horizon.

Shoot Signs

By photographing signs, billboards and posters, you can make instant titles that, themselves, tell the story of your trip. Move close and fill the frame with the sign, but don't stick to just head-on views. Angle the camera steeply upwards, for example, to show the sign against a blue-sky background. You can minimize reflections and brighten colors by using a polarizing filter.

En Route

Look for pictures that will define the start of your story.

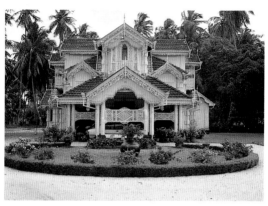

The Hotel

Yours may not be as exotic as this, but even the humblest accommodation is worth a picture — after all, it will be your base until you return home.

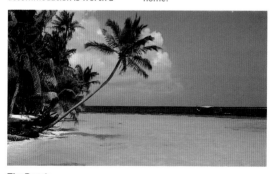

The Beach

Aim to catch a good overall view — other pictures can fill in the details.

Be Selective

When you return home, it is important to be very selective in your choice of pictures, and to present them well. Weed out any substandard images, and try not to be repetitive. Remember that people's attention quickly wanders, so it is better to show too few pictures than too many.

Put the pictures in sequence in an album or slide show so that they are viewed in the order you have chosen — don't just pass around postcard size prints. In an album, you can vary the scale by making enlargements from the better photos, and by trimming others to remove unwanted details at the edges.

Look for Color

Pictures like these provide brilliant punctuation marks in the narrative, and help to set the scene.

Beach Games

Scenes of activity have more appeal than images that just show friends and family lounging on the sand.

A Fishing Trip
Don't forget to show the catch.

◀ Don't Be Too Serious
There's always a place for traditional vacation snapshots.

Sundowners
A sunset picture clearly says "day's end"

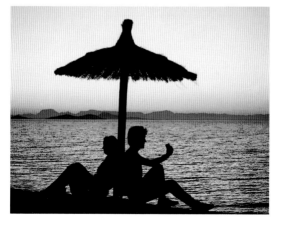

ANIMALS AND BIRDS

Wildlife is surprisingly localized, and even a short journey, particularly from city to country, will provide the opportunity to see and photograph new and unfamiliar species. However, to get really worthwhile pictures of these living subjects, you'll need to do some planning and preparation. The first step is to read a little about the most common species in the area you will be visiting. Then you'll be able to pinpoint exactly which creatures you wish to photograph and find out where they are most likely to be found. By learning about their habits, you'll avoid the frustration of waiting too: don't expect to get pictures of the most timid animals unless you have a lot of time and patience.

The animals you aim to photograph will dictate what equipment you'll need. Unfortunately, simple fixed-lens cameras are suitable for picturing only large wild animals at close range — an unlikely occurrence. When photographing most free-ranging animals, a 35 mm SLR camera with a tele lens is a much better choice. With large mammals — particularly those that move around in herds — a 200 mm lens will provide sufficient magnification. But for all smaller animals, including birds, take a 400 mm or longer lens.

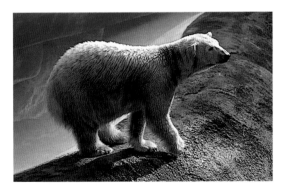

Pictures in Zoos

In captivity, wildlife is certainly closer and easier to see, but bars and unnatural backgrounds often spoil pictures. Use the techniques outlined on the opposite page to cope with the problems.

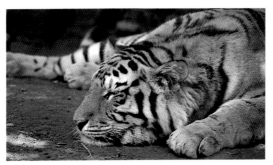

Barriers

You can make bars and netting disappear by moving very close, and pressing the camera against the barrier. Then set the lens at a wide aperture. The shallow depth of field this produces will throw the barrier out of focus — particularly if you use a telephoto lens.

Backgrounds

In some respects, unsightly backgrounds are more difficult to cope with. Again, shallow depth of field can conceal details of background texture, but not color or tone. Try waiting until your subject moves in front of a patch of foliage or shadow before taking the picture, or else get down low so that the sky forms a background. If the animal is moving quickly, you may be able to pan the camera to hide the background in flowing streaks of light, as you would for other action subjects. (See pages 74-5.)

Finding Wildlife

When time is short, as it often is on vacation, the only practical way to get close enough to photograph

wildlife is to head for known habitats. The surest way to identify such places is to enlist local assistance. In popular tourist destinations, some people make a living as professional guides. In other places you may be able to get amateur help. For example, if you want to photograph birds, contact the local ornithology society. In wildlife parks and game reserves, there may be permanent blinds and viewing platforms. These not only provide a grandstand view, but also reduce the risk of visitors disturbing the animals they are watching.

PARKS AND GARDENS

A city park or formal garden is a landscape tamed by human hand. Here, different flowers that would never be seen together in the wild bloom side by side. The random forms and spacings of trees and shrubs become orderly, rhythmic patterns of clipped shapes. This regimented arrangement provides many opportunities that never occur in photography of the natural landscape. To make the most of town or city parks, you must approach them differently from craggy hills and rolling rural fields. Don't try to conceal the artificial nature of the scenery. Instead, take advantage of the sense of order and control that governs the layout and planting.

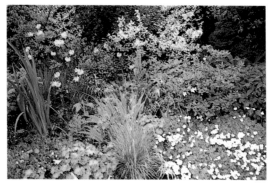

Orderly Gardens

Match your technique to the style of the garden you are visiting. Some gardens are planted in a mathematical, orderly manner; and with these gardens, you might choose an approach that exaggerates the perspective effects that straight lines and regular spacings produce. Avenues of trees always look dramatic: stand at one end to make strong diagonals converge into the distance, and use a wide-angle lens to make the majestic sweep of foliage look even more grand. Not all gardens are laid out with military precision,

though. Historic European parks, for example, and plantation estates in the South were arranged to take full advantage of the existing terrain. Only closer examination reveals that everything is not as nature created. When photographing these places, bear in mind that the entire estate was laid out to give pleasure to the landowner and to impress guests. You'll usually find the best views on your way up the drive — particularly near the gates — and looking out from the viewpoints close to the house itself.

Flower Beds

Flowers are an obvious attraction in parks, but take care to avoid a garish display of color. Be selective, and choose a viewpoint that shows just one or two dominant hues, with other details forming a contrasting background — not a division of interest.

Seasonal Color

Don't visit parks only in the spring and summer. At other times of year, foliage plants make subtle contrasts of green and brown, and the parks are less crowded with visitors.

Focus on People

Parks and gardens are ideal locations for human-interest pictures, because there is always something going on.

Even in winter you'll find people walking, jogging, feeding the ducks or just relaxing.

BY THE SEA

Seashore pictures are usually just fun-on-the-beach snapshots, yet most coastal areas have plenty more to offer the vacationing photographer who looks beyond that narrow strip of sand. The sea itself changes constantly to the double rhythms of tide and time, and the weather, too, changes more rapidly on the coast than inland. So even a single view can look completely different in two pictures taken hours apart. Turn your camera inland, and you'll find many more subjects — a whole world of photogenic things associated with the sea, such as harbors, boats, fishing activities, and ships' chandlers.

Whichever aspect of the seaside area you choose to photograph, you'll need to adapt your picture-taking technique. Your camera must be protected from salt and sand, which can quickly cause damage. And with filters, you can often add extra color to the scenes you photograph.

Low Tide

As the tide changes, so too does the appearance of a port or beach — so make several visits.

Safety First

Protect your equipment by taking only an absolute minimum with you to the beach, and as an extra protection against sand and salt, wrap all items in plastic bags before putting them in your camera bag. Use a skylight filter on each lens to protect the front element from damage.

Once you are taking pictures, try to avoid blown sand and spray, which can easily penetrate the crevices in cameras and lenses. For the same reason, change lenses and film only in sheltered places. You can remove blown sand using a soft brush or a rubber blower bulb, and salt spray with a soft cloth or tissue dampened with fresh water.

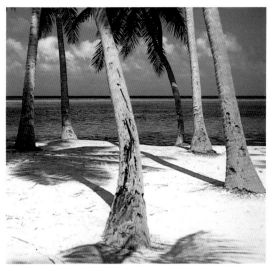

Exposure and Filtration

Light sand and reflective water make the seashore very bright as in this picture, and exposures for general views may be shorter than usual. However, the bright light can mislead your meter when you take close-ups, or pictures of people on the beach. You can prevent this by moving close to your subject to take an exposure-meter reading, then moving back to recompose the picture. This way, the bright background will not influence the meter reading. If you are using extremely fast film, you may find that even the smallest aperture and fastest shutter speed will result in overexposure. With color negative film the problem is not severe, as the film can cope with the small errors involved; but with color transparency film, overexposure is disastrous, and you should either change to a slower speed film or fit a neutral density filter over the lens. A 0.60 ND filter will reduce the amount of light reaching the film by the equivalent of 2 stops.

Other filters can improve your beach pictures, too. Use a polarizing filter to make colors richer and brighter, and to reduce the amount of light reflected from the sea. A polarizer absorbs about 1 ½ stops of light, so it can double as a protection against overexposure. Seaside scenes are rich in ultraviolet radiation, which can cause a bluish color cast on film — a skylight filter will absorb UV and prevent this. An 81A or 81B filter will also counteract the bluish cast and have the added advantage of warming skin tones, so people look more tanned.

MOUNTAIN SCENERY

Mountain scenery is awe-inspiring to look at, but on film, even the loftiest peak will lose its grandeur unless your pictures convey the overall scale of the scene. If you are using a simple camera, you can suggest scale by deliberately including a familiar object — such as a tree, house or figure — in the middle distance. This will give the viewer something to which the size of the mountain can be compared.

With an SLR camera, changing lenses provides extra scope for suggesting depth and distance. A wide-angle lens will include in the picture foreground detail to enhance the impression of perspective — perhaps emphasizing the effect of a high viewpoint. However, this approach can also diminish the sense of scale, so that distant mountains appear dwarfed in relation to closer objects. The most effective way to preserve a true sense of relative scale is to use a telephoto lens to isolate a small area of the distant view so that the mountain is seen in comparison to smaller objects nearby.

Telephoto lenses have another desirable effect, too: they exaggerate atmospheric haze, making distant details appear progressively lighter at increasing distances from the camera. This effect is called aerial perspective, and looks particularly effective when the picture consists of successive mountain peaks stretching away to the horizon, as in the picture below.

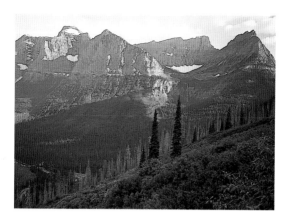

Mountain scenes can create tremendously high contrasts: sunlit snow is many times brighter than dark rock in shadow. Though these high contrasts make dramatic pictures, they also make exposure metering difficult. If you are photographing sunlit peaks, the most reliable answer is to take two meter readings — one from the deepest shadow area, and one from the brightest highlight. Set the exposure midway between the two readings.

Filtration

At high altitudes, use a UV or skylight filter to reduce ultraviolet radiation exposure on the film. Without a filter, your pictures will have a slightly bluish color cast. You'll need extra filtration if your subject is in the shade of a mountain, and lit only by the blue sky. In these conditions use a pale brown 81C filter. Snow-covered scenery needs no special filtration when the sun is shining on it, but in dull weather, and when the whole scene is in shadow, use an 81C filter.

Making Snow White

When snow covers the whole of the scene you are photographing, allow two stops extra exposure compared with the setting recommended by your camera's meter. If people appear in the picture, take a close-up reading from their faces to get acceptable correct exposure.

TAKING A BROAD VIEW

When we look at a breathtaking view, our eyes scan the scene, and we focus attention on the things that particularly interest us, passing over the boring or unattractive aspects. However, when we point a camera at the same view, this does not happen — the camera records everything with equal emphasis. The result is that sometimes the main area of interest is submerged in irrelevant detail, and instead of capturing the charm and beauty of the countryside, we draw attention to a barbed wire fence or telephone cable that went unnoticed at the moment of exposure.

For this reason, it is especially important to take a good look at a scene which attracts you. Evaluate exactly what it is that motivates you to take the picture. Next search the scene for any distractions which might spoil the effect. This will enable you to decide how best to frame and compose the image to emphasize the good points and eliminate or conceal the bad ones.

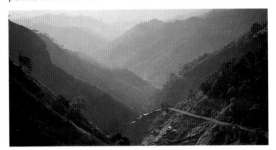

Start with a normal lens . . .

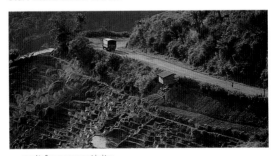

. . . wait for some activity . . .

Select and Edit

The key to photographing a scene lies in selection. Usually you'll find that what makes a scene interesting is not the broad, sweeping horizon, but the details or activity in one restricted area. Think of a farming scene. Most of the view consists of fenced-in livestock and ripening crops stretching to the horizon. What draws the eye, though, is the busy farmyard in the middle. Closing in on this small area will make an interesting picture, whereas a broader view would emphasize the fields, and the farmyard activity would look insignificantly small.

You can improve your pictures of scenics by making a habit of raising the camera to your eye — even if you don't take a picture. Looking through the viewfinder, you can train yourself to see the world through the camera's frame. Of course, taking pictures provides better practice and enables you to monitor your ability. Try photographing, or at least seeing through the viewfinder, the same view in half a dozen different ways,

as shown here. Alter the composition by making the horizon higher or lower, or by pointing the camera further to the right or left. Take vertical photos, as well as horizontal; and if you have an SLR camera with a zoom lens or two different lenses, try taking the same scene at several focal lengths. From a comparison of the resulting pictures, you will be able to see how many different pictures you can edit from the same scene.

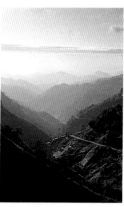

. . . try turning the camera . . .

. . . or close in on a detail.

ABSTRACT LANDSCAPES

Traditional landscape views draw attention to the location and identity of the subject. But just as valid is an abstract approach, in which the "what and where" of the scene is less important than the picture as a whole.

The photograph you take will eventually be seen as patches of color and tone on a flat piece of film, paper or screen, and you should think of this as you look at the scene in front of you. Try to ignore the effects of depth and distance, and treat the subject as an arrangement of shapes on an imaginary canvas held out at arms length. If you find this difficult, close one eye, so that you see the scene more like the camera's one lens sees it.

Abstract landscapes don't need to show a broad view; you can also make great pictures by closing in on a gnarled tree stump or a wind-scored rock. And you need not show the colors of the scene, either — black-and-white film helps you take an extra step back from reality, so many photographers choose monochrome when making serious, abstract landscape images.

Use Shadows

The sun can turn undulating scenery into interlocking triangles of light and dark.

◀ Concentrate on Color

Look for areas of bright color, with sharp boundaries in between.

Take a Distant View

Telephoto lenses flatten the view, and help you make bold patterns from the landscape.

PICTURES ON THE MOVE

Traveling by road, rail or air can be like watching a movie. A new scene — and a new picture opportunity — flashes by every few seconds. Don't pass up these great photos simply because you're inside a vehicle: even if you cannot open the window, you may still be able to get an acceptable image. And by including part of the vehicle you're traveling in, or your traveling companions, you can take pictures that say as much about the romance of travel as they do about the scene outside.

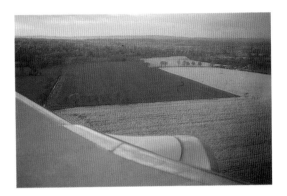

Pictures from Aircraft

You can improve your chances of getting good pictures from a commercial aircraft, starting at the moment you check in. Make sure you get a seat by the window, and that a wing does not block your view.

The double layer of plastic in every window unfortunately reduces the sharpness of pictures, but the fall in quality is less marked when the window is in shadow: direct sunlight reveals every scratch. The plastic material also can create rainbow colors when light from a blue sky falls on it. This effect is caused by polarized light and is made worse by a polarizing filter, so don't use one unless you want brilliantly colored pictures.

To hide reflections in the window, get as close to it as possible, but don't rest the lens against its surface, or vibration from the engines will spoil the picture.

Camera Settings in the Air

In flight, everything is in the distance, so set the focusing scale to infinity (∞). Use the widest possible aperture, and a fast shutter speed to eliminate camera shake. Use the camera's meter in the usual way.

When to Take Pictures

Time of day will affect the success of your photographs from the air. Just before dusk and at dawn the sun is low in the sky, causing long shadows, so objects on the ground appear in sharp relief. Shoot several pictures during take-off and landing because detail below shrinks rapidly as the aircraft climbs. Higher up, the view is usually fairly monotonous but at sunset and sunrise, cloudscapes can change rapidly, so try to be awake at these times.

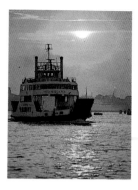

Stretch Your Legs

Even during short stops there's time to take pictures that evoke the mood of your journey.

On the Water

Shooting into the light lets you use a faster shutter speed to combat camera shake.

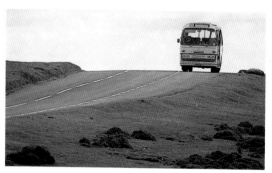

Ground Transport

On moving boats, autos, buses and trains, you can reduce the problems caused by windows and vibrations just as you would on a plane. But on the ground, there is another difficulty: motion blur. Though air travel is faster, objects appear to flash more quickly past the windows of ground transportation. A fast shutter speed can freeze this movement, and you can also use the panning technique explained on pages 74 and 75 to follow the stationary objects that you pass. Don't ignore the possibilities offered by slow shutter speeds though. At 1/60 second, the distant skyline will be sharp, but nearby subjects form bold horizontal streaks.

SHOOTING IN SUNLIGHT

Vacations and sunshine are inseparable. Most of us take our annual break in the summer months when the hours of sunlight are longest and take more pictures then too. Ironically, a sunny day can make good photography more difficult, rather than easier. This is because the sun casts deep shadows that cut black patterns across pictures. Sunlight also makes brilliant reflections that burn highlights out to featureless white on film. Getting really good pictures in sunlight means controlling these harsh contrasts — either reducing their bad effects, or turning them to your advantage.

The effect that the sun creates depends on its position. With the sun overhead, shadows are small, and directly below the subject. Consequently, pictures taken at noon tend to look rather colorless and give an impression of searing heat. For midday portraits, it's best to avoid this unflattering light, and instead take pictures in the shade.

Low sun creates quite a different effect. With the sun

positioned low and behind the camera, shadows on the subject are at their smallest, and colors at their brightest. To enrich hues even more, use a polarizing filter, and underexpose slightly. For close-ups, this low frontal lighting can be quite flattering, provided that the sun does not make your subject squint too much.

With the sun at your side, shadows become quite long and dominant, so the image consists of half shadow and half highlight. This dramatic, raking light is ideal for revealing form and texture, and for bringing out character in a face. Take care, though, with close-ups — such side lighting does not necessarily flatter the subject.

With the camera facing the sun, the subject will be completely in shadow and will form a graphic silhouette when against a bright background. Color pictures taken under these conditions often look monochromatic, because contrasts are so high. For close-ups, backlighting is good — provided that you set the exposure to suit the subject, not the sun behind. These are extreme examples, and for much of the day, the sun is not hovering on the horizon or directly overhead, but somewhere in between, so that light slants down onto the subject at an angle. This diagonal lighting is more moderate and will create a mixture of the two effects described above.

Perfecting Skin Color

When using color slide film to take portraits of people standing in the shade, blue skylight can sometimes create a color cast in your pictures. Fit a straw-colored 81A or 81B filter over the lens to visually warm the scene.

Softening Shadows

For backlit or sidelit close-ups, you can lighten deep shadows by using a flash unit, as described on pages 70 and 71; but the simplest technique is to move the subject close to a light-toned surface. A white fence, light sand — as in the picture above — will do.

BAD WEATHER

When the sky darkens and raindrops splash all around, most of us run for cover, and put our cameras safely away. Bad weather, though, doesn't always mean bad pictures, and photographs taken in mist, rain or snow may actually capture the spirit of your travel destination much better than sunlit snapshots. After all, what could be more evocative of the quiet beauty of Cape Cod — or perhaps Venice — than a view shrouded in the mist that drifts gently through these places?

Protecting Your Camera

Water can harm your camera, so you must take steps to keep it out. In drizzle, you can simply wipe off small amounts of water with a dry cloth or tissue. But in heavy rain, you need to take more care. Photograph from the shelter of a doorway, through an open window, from under an umbrella or shop awning. For taking pictures outdoors in stormy weather, you can improvise a waterproof enclosure for your camera as at right.

Cold weather cannot damage your camera, but the condensation that forms when you come back into a warm room certainly can. Before stepping indoors, wrap all equipment in plastic bags, and allow a couple of hours warm-up time before removing your gear.

Set Up for Storms

Weatherproof your camera with a large plastic bag, as shown here. Cut a hole for the lens, and use waterproof tape to seal the bag to the lens shade.

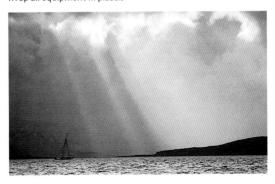

Exposure and Filtration

Storms, mist and snow create unusual lighting conditions that can mislead your camera's meter. For example, your camera may interpret the brooding darkness prior to a storm as just a dark subject — and the resulting photographs will have none of the angry atmosphere of the original storm. Compensate by deliberately underexposing stormy scenes by 1 stop.

In mist and snow, the reverse is true. The light surroundings will look gray on film, if you let the camera make the exposure decisions. Allow 1 extra stop exposure to capture the whiteness of these conditions.

With the exception of sunlit snow scenes, bad weather makes the light appear bluer

than usual. If you are using slide film, use an 81B or 81C (or No. 1A skylight) filter to prevent your photographs coming out with a bluish color cast — this will also protect the lens surface.

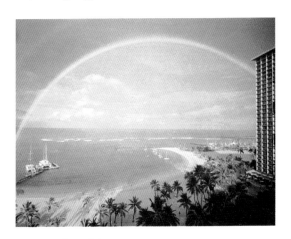

Photographing Rainbows

After the storm, look for the rainbow. Stand with your back to the sun, and you'll be facing that part of the sky where the rainbow appears. You'll capture the colors most clearly if you underexpose by one stop.

EMPHASIZING SKIES

Even when the landscape is ugly, colorless, or just plain dull, there's one subject that puts on a constantly-changing show of color, light and pattern. Perhaps we rarely think of the sky as a subject because it hovers behind each and every outdoor scene that we look at. The abstract swirls of blue and gray are so familiar that they only get noticed when they're gone, and are replaced by dark stormclouds, or the vivid hues of sunset.

So if you despair of finding a worthwhile subject for your camera, just look up, and you'll see a picture that's never the same twice.

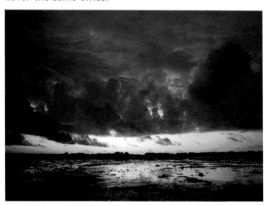

Storm Clouds

Don't take just one picture of a stormy sky. At these times, light changes rapidly and each picture in a series may look totally different.

The sky doesn't look its best in the middle of the day — around noon, sky colors are at their least brilliant, and the glaring overhead light washes out your pictures. Photograph towards the beginning and end of the day, if you want to catch the most spectacular views. At these times the direction of the sun is still important.

For maximum color, keep the sun at your side, but don't overlook the possibilities of backlighting on clouds. When a cloud passes in front of it, the sun sometimes creates a brilliant ring outlining the cloud against the sky. Windy days with broken cloud cover create some of the greatest variety of sky pictures. The clouds appear alternately dark and light as the sun disappears and reappears. And when gaps in the clouds are small, brilliant shafts of light spotlight the land.

Darkening Skies

Add drama to black-and-white sky pictures by fitting a red filter over the lens.

Expose for the Sky

For maximum color saturation in the sky, point the camera up to take a meter reading. Remember, though, that this may record the land beneath as a silhouette.

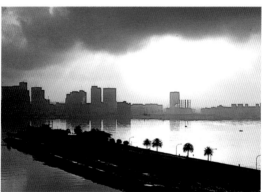

Lenses and Filters

If you have two or more lenses, use them all. With a telephoto lens you can make tightly cropped cloud portraits, and with a wide-angle lens, you can show off the subtle variety of hues in a sky that, to the eye, appears uniformly blue.

Filters exaggerate existing hues, or add impossibly bright colors for a surreal look. The most useful filter of all is a polarizer — it makes blue skies look bluer, but has no effect on gray days. Rotate the filter while looking through, and scan the sky to find the most effective setting and camera angle.

Graduated filters help bring out skies, too. For natural-looking pictures, use a gray filter. It will simply darken the sky, so that there's more detail there and on the ground below. Colored graduated filters add pizazz, but reserve them for occasional pictures — used too often, they become routine and obvious.

SUNRISE AND SUNSET

Most photographers find sunsets irresistible. Indeed, a sunset picture is often the strongest and most colorful image in a travel album; and if you are in a good location towards the end of the day, it's well worth waiting to catch the last glimmer of the day. Because sunsets can be difficult to record faithfully, you'll want to take several pictures to be absolutely sure of getting one good one.

Exposure is the crucial factor. A sunset is an exceedingly high-contrast subject, and assessing the exposure isn't easy. The simplest method of getting approximately the right exposure is to aim the camera at the area of sky just to one side of the sun, then use the indicated exposure as a starting point for three or five bracketed pictures. Take one picture as the meter suggests, then give 1 stop more exposure, and 1 stop less. To be doubly sure, take pictures at 3 stops more and less as well. The exact appearance and hues of each of these pictures will be slightly different, but it is almost impossible to judge in advance which one will look the best.

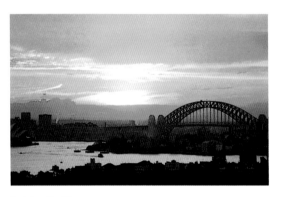

Judging the Moment

Many sunset pictures are disappointing because they were taken too early, when the sun was too high in the sky. It is best to wait until the sun touches the horizon, or descends into a bank of cloud or haze. When this happens, take pictures quickly, as the light changes fast.

Sometimes you'll get better results if you wait until the sun has actually disappeared. Twilight produces some of the richest and most unusual colors. Take care, though, to provide extra camera support as exposure can be long.

Capturing Foreground Detail

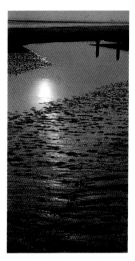

The ideal exposure for an evening sky will almost always cause the foreground to be underexposed. If there is an area of water — even a puddle will do — you can use this to reflect the sky's colors as shown at the left, but otherwise, detail near the camera will be much too dark. One solution to the problem is to use a neutral gray graduated filter to darken the sky. With the clear area of the filter positioned at the bottom of the lens, you can then increase the exposure by 1 stop to lighten the foreground.

Alternatively, use a flash unit to throw some light on those areas near the camera.

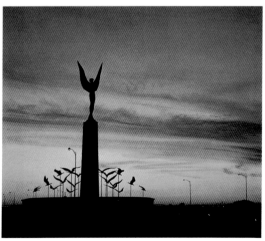

Making Silhouettes

Look for bold, graphic shapes against the evening sky. They will form attractive silhouettes, and make a dramatic contrast with the setting sun behind.

COPING WITH LOW LIGHT

One of the great joys of travel is lingering over evening meals with family and friends, and meeting new people in candlelit cafes. To record these occasions on film, the natural reaction is to supplement the existing light with a flash unit. However, the warm, soft light from lanterns, candles and table lamps is an essential part of the mood of restaurants and cafes — and by comparison, the cold, direct beam of a flash unit can make even a dinner for two seem about as intimate as a business meeting. If you make the most of existing light, your pictures will capture as closely as possible the atmosphere of your vacation nightlife.

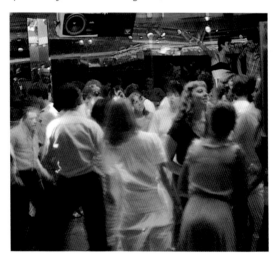

Filters for Slides

Compared to daylight, all artificial indoor lighting (except fluorescent tubes) gives out a warm yellow glow. If you use daylight-balanced slide film, this will create a yellow color cast on your pictures. For completely natural colors with daylight-balanced film, you may have to use several filters, but usually in such informal surroundings as the disco shown here, partial correction with an 80A filter is all that is needed. Negative film such as KODACOLOR VR 400 and VR1000 Films may give pictures slightly more yellow than normal, but generally acceptable colors. In your home darkroom or with custom printing, the colors can be adjusted to appear natural and lifelike.

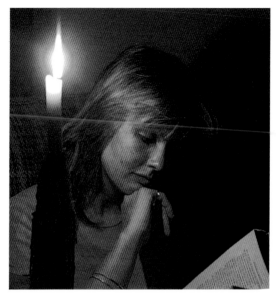

Pictures by Candlelight

Fast film will help you get good pictures in these dim conditions. KODACOLOR VR400 and KODACOLOR VR1000 Films are good choices. With KODAK EKTACHROME film for color slides, you can set the camera's film speed dial to double the normal ISO rating, and ask the lab to compensate during processing for the resulting underexposure. Note that the whole roll of film must be exposed at the higher index, not just one or two frames. To set a shutter speed fast enough to enable you to hand-hold the camera, use a wide aperture — preferably the maximum aperture of the lens. At such large apertures, depth of field is very shallow, so take special care in focusing.

Setting Exposure

Very dark corners will come out as black pools in your pictures, so try to frame the images in such a way that brightly lit areas dominate the composition. Set the exposure by closing in and taking a meter reading from a highlight, such as the face of someone near a lamp. You can judge how dark other parts of the picture will be by taking meter readings from them. The areas of the scene that will disappear in darkness are those that call for at least 2 stops more exposure than the bright area on which you based your exposure settings. If anybody's face seems likely to come out too dark, move them closer to the light source to even out the lighting.

LIGHTING FOR ATMOSPHERE

Making a good likeness on film of the places you visit and the people you meet isn't usually very difficult. Sometimes, though, one picture stands out from the rest because it reveals the atmosphere of a place or the personality of a traveling companion. Look more closely, and you'll find that the success of this picture oftens results from lighting. The way the light falls as you press the shutter release is a major factor in creating mood in pictures.

Evening light, for example, throws long dark shadows which make a far more evocative background for a portrait than the sharp clear light of noon. In the same way, the light of a heavily overcast or stormy sky helps to create atmosphere in a landscape picture. Atmosphere does not mean just "dark and moody", though, and it is important that the atmosphere created by the lighting is appropriate to the subject and to the impression that you want your picture to give. A harsh midday sun, for example, would most effectively convey the atmosphere of a parched landscape, and the bleak, gray light of a dull day would create the right mood for a wintry scene.

To understand these lighting effects, try to see the image in terms of tonal quality — how much is dark, how much is light, and how light and shade are distributed across the picture.

Low-key Lighting

When shadows dominate the image, the mood is sombre, mysterious or subdued — in musical terms, the picture is in a minor key.
Photographers, in fact, describe this kind of lighting as "low-key". Low sunlight naturally creates large shadow areas, but you can generate the same sort of feeling in your pictures in other kinds of lighting by deliberately hunting for deep shadows against which to place your subject, and by giving less exposure than your meter indicates. Make sure, though, that the main subject is adequately lit.

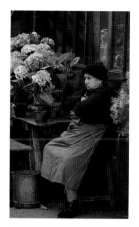

◄ Normal Tones

A normal photograph consists of a wide range of tones, from highlights, through a range of middle tones to a black. This is the kind of image that regular morning or afternoon sunlight would create, or that you would produce when taking pictures indoors with the subject close to a window. This even lighting makes for pictures that look bright and lively, and that record most parts of the subject with equal emphasis. With such scenes, the camera meter will usually give an exposure that faithfully reproduces the scene.

High-key Pictures

A high-key image is one in which light tones dominate. This type of picture suggests a light, airy atmosphere — one of gaiety and excitement. In a portrait, high-key lighting creates a gentle, delicate look. On color film, high-key images are suffused with soft pastel hues, rather than the rich dark colors of a low-key image. Overexposure helps in creating high-key pictures, but a light toned subject and the right lighting are more important. Misty or hazy conditions are ideal for high-key views, and soft frontal lighting of any type is equally effective.

COLOR AND MOOD

Just as lighting can create or enhance a particular mood, so too can the color of a subject. Each color in the spectrum has associations with a particular emotion, and this can unconsciously affect the way that we respond to a picture. For example, an image dominated by red invariably has a bold and assertive quality; orange and yellow create warm, inviting atmospheres; blues are cold and aloof; and greens suggest a restful, peaceful mood; indigo and violet have a sombre, subdued feeling. In addition, the depth and saturation of color have an important effect on mood. Strong bright colors look lively and exciting, whereas soft pastel shades seem romantic and gentle.

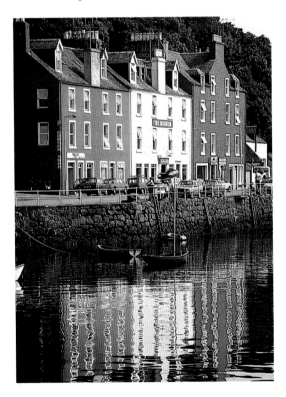

Single Color Pictures

Framing your picture to include just one hue enables you to let color totally control the mood of your picture. In the cities you visit, look for brightly colored store fronts, buildings, doors, fences, and vehicles. In rural areas, crops can make brilliant colors at certain times of the year: think how the color of ripening wheat vividly evokes the sensation of a hot summer's day.

◄ Color Discord

To create excitement or unrest, frame the picture to include clashing colors. Often you can do this with clothing — use the bright colors of your friends' outfits to strike discordant notes from contrasting backgrounds.

Color Harmony

For quiet, soothing pictures that are easy on the eye, look for colors that harmonize. Frame blues and greens together, and mix warm colors such as oranges and reds.

INDEX